Shooting with Soul

44 Exercises Exploring Life, Beauty, and Self-Expression

Alessandra Cave

Quarry Books
100 Cummings Center, Suite 406L
Beverly, MA 01915

quarrybooks.com • craftside.typepad.com

© 2013 by Quarry Books

First published in the United States of America in 2013 by
Quarry Books, a member of
Quayside Publishing Group
100 Cummings Center
Suite 406-L
Beverly, Massachusetts 01915-6101
Telephone: (978) 282-9590
Fax: (978) 283-2742
www.quarrybooks.com
Visit www.Craftside.Typepad.com for a behind-the-scenes peek at our crafty world!

10 9 8 7 6 5 4 3 2 1

ISBN: 978-1-59253-871-3

Digital edition published in 2013
eISBN: 978-1-61058-922-2

Library of Congress Cataloging-in-Publication Data available

Design: Studioink.co.uk
Photography: All photography by Alessandra de Souza Cave
Developmental editor: Nancy King

Printed in China

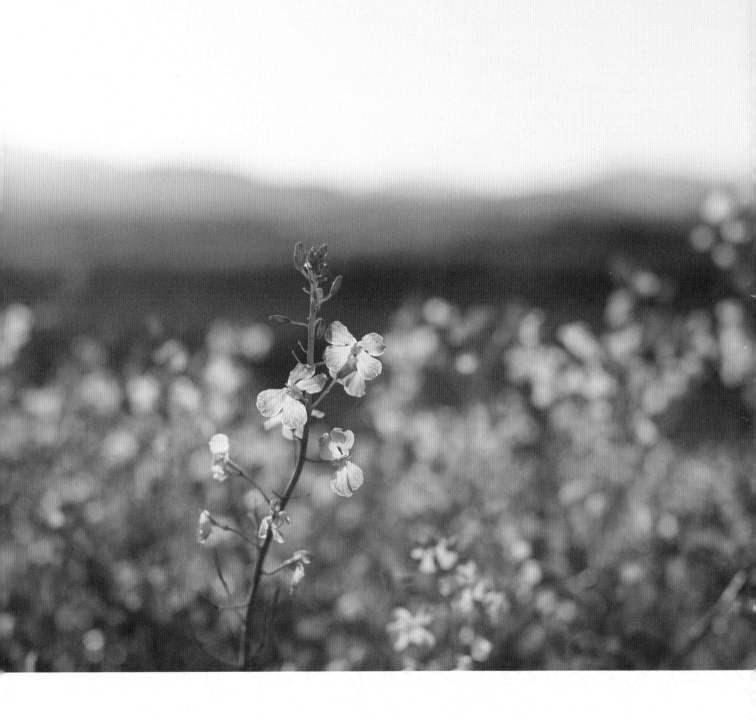

To my daughter, Gabriella—Always believe in your dreams.

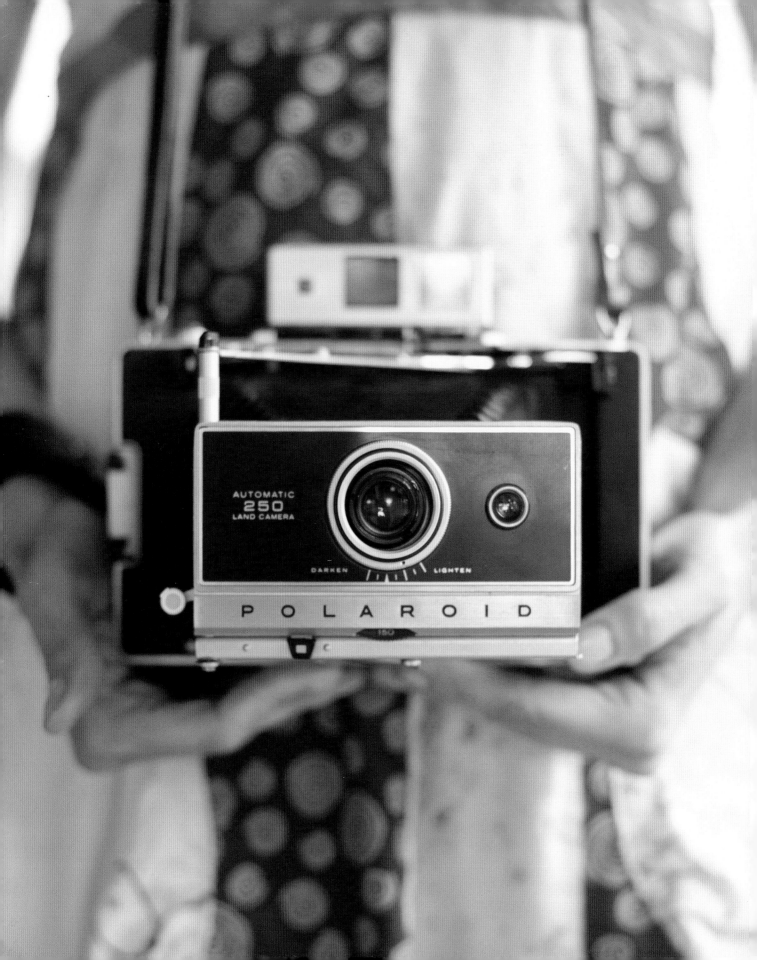

Contents

Introduction

Photography found me early in life, in my teen years, but I only took it on as a life practice in my late thirties. As you can imagine, for a self-taught, late bloomer like myself, the challenge of writing a book on photography triggers all sorts of vulnerabilities. There are many talented, well-known, and skilled photographers in the world who could have been tasked with writing this book. So, why me, I asked myself over and over. What do I have to offer? Ironically, in the answer lies the whole premise of this book. All I have is my soul. I have my own way of distilling information, processing ideas, and sharing what I know. And I have the desire to be here and to do this for you with an open heart. As someone who has undergone many life transitions, such as moving abroad very young and changing careers in mid-life, I am a firm believer that everything that we have ever done and experienced contributes to what we have to offer. The truth is that regardless of how much we know about anything, all we really have to offer, in full integrity, is ourselves. From my childhood drawings to studying illustration, traveling the world, obtaining a Master's degree in Arts, and working in the advertising and film industries for over fifteen years years, I have lived and breathed images all my life. This book is the culmination of what I have learned and seen so far. My hope is that my voice will resonate with you and inspire you to find your own voice.

"The truth is that regardless of how much we know about anything, all we really have to offer—in full integrity—is ourselves."

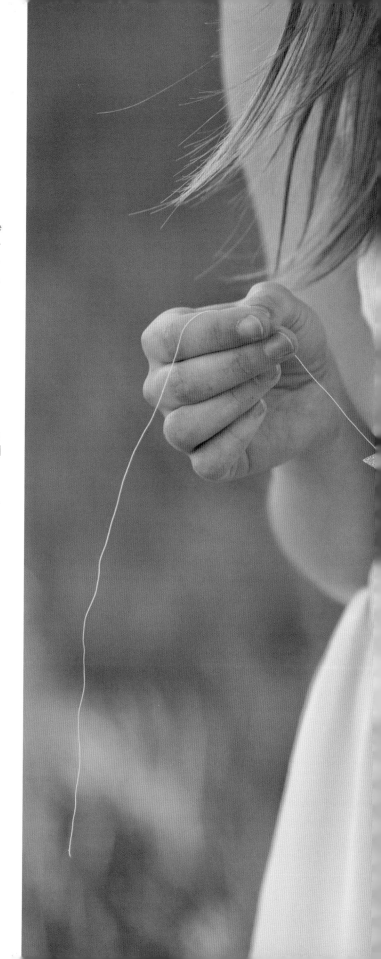

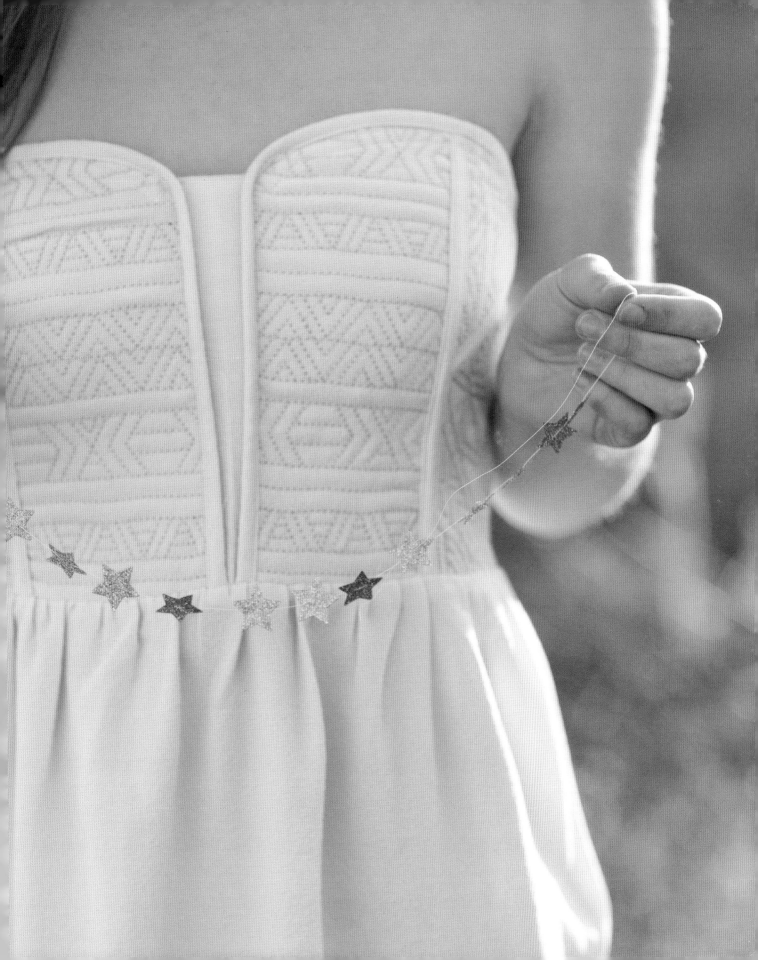

How to Use This Book

My original goal was to share insightful tips and tools that would empower you on your photographic journey. But once I started working on this book, I realized that I wanted to offer a lot more than that. I also wanted to offer you the opportunity to cement the practice of photography with an ongoing, long-term project. The commitment required to stick with a project for a whole year mirrors the effort necessary to create art that comes from deep within our souls. Sure, we can buy fancy cameras and snap photos here and there. But to dive into our process with absolute devotion and commitment is another story. I offer you that opportunity here. Commit to following through on a yearlong adventure.

Give yourself about four weeks to work through the "Getting Started" section, taking about a week to study each topic. Then you will have 44 photography exercises to explore at your own pace. Dedicate about a week for each project. I promise that if you keep shooting week after week, you and your photography will be forever changed. Finally, give yourself another two to four weeks to spread your wings and learn about sharing, printing, and connecting with other photographers. At that point, you might just be so excited about your photos that you will want to keep this project going year after year.

Throughout the book, you will find some technical terms in **bold**. Feel free to look up their definitions in the "Type of Lenses" sidebar that appears in Chapter 1, or in the Glossary at the end of the book. In each exercise, you will find a short introduction, a personal story, and instructions to get you started. Then it is your turn to dig deeper and draw from your own stories and emotions as you shoot. It takes great courage to trust what we know, to be who we are, and to let go of comparison. I invite you to be gentle with yourself as you begin to peel back the layers of inhibition and self-doubt to unveil your unique style. Stay focused. Keep going despite any distractions, detours, and interruptions that may come your way. Keep shooting through all the messy in-between moments. Let this book be a map to your heart. Let it be a guide to sink a little deeper into your life, to look a little closer through your lens, and to get more in tune with the whispers of your soul. I assure you that the practice of shooting continuously, from a soulful place, will make all the difference in how your images turn out.

My greatest hope is that by working with the tips and with the process suggested in this book, you will find a window into your soul—and also find joy—as you unleash your vision of the world! If I can do it, then you can do it too. Be brave and have fun!

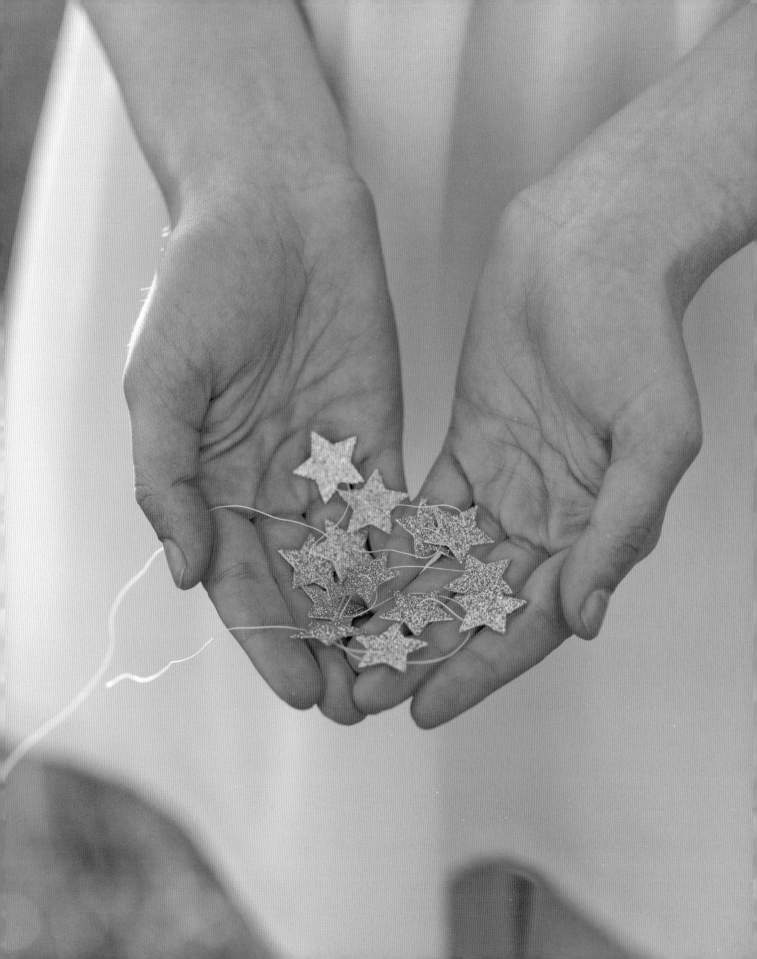

Chapter 1

Getting Started

Choosing Your Camera

As you embark on this journey to shoot images with soul, you should dive into this adventure knowing that your camera is not what matters most when it comes to creating images that you and others will love. The real magic comes from your heart and how you see the world in your own unique way.

That said, the camera is the tool that will enable you to capture your imagination, life experiences, and feelings. As an extension of your eye, the camera needs to match your sense of aesthetics, and it needs to allow you to shoot consistently, intuitively, and with confidence.

BELOW: Land Cameras are vintage instant cameras that take Fuji FP-100c, FP-100c Silk, and FP-3000b peel-apart film. See the Resources section for more information. Featured prints are by Andrea Corona Jenkins.

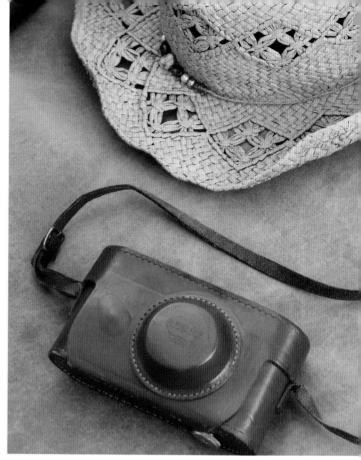

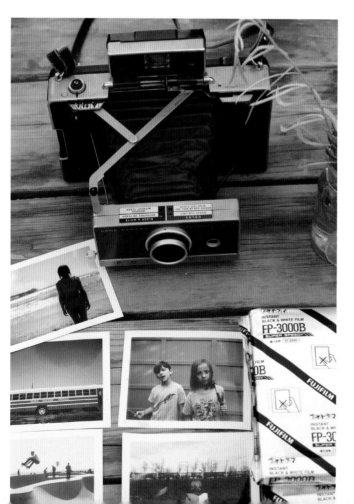

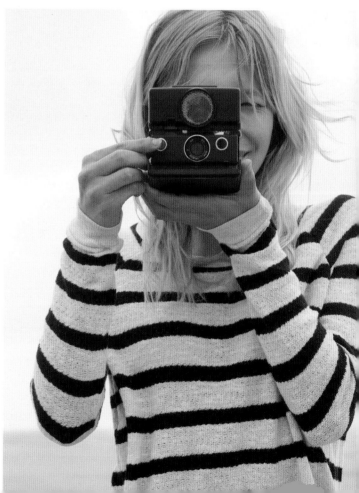

Aesthetics

Your sense of aesthetics is your artistic sensibility. It is your sensorial and emotional response to what is beautiful.

With that in mind, you should begin your quest for the right camera simply by noticing what kinds of images you are most drawn to and by paying attention to the cameras that were used to obtain those results. Remember that there is no right or wrong here. Just stay true to yourself and notice what aesthetic qualities you may want to explore in your own photography.

Functionality

It is through your daily practice that you will begin to develop your visual voice and style, so apart from aesthetics, you will also need to consider what features will keep you motivated to shoot consistently.

I get frustrated when a camera pulls my eye away from the viewfinder to change settings for each shot. For that reason, I tend to favor cameras that allow me to stay fully in the moment and shoot without any technical distractions.

It is true that every camera will require you to gain some experience on how and where to change settings. But with practice, you should be able to adjust your basic camera functions without having to search through several menus. I encourage you to look for cameras designed to make shooting easy and intuitive.

OPPOSITE, TOP LEFT: The Argus C3 is a 35mm film rangefinder camera with lots of vintage appeal.

OPPOSITE, BOTTOM LEFT: The SX-70 is a popular vintage SLR instant camera that was produced by Polaroid from 1972 to 1981. The Sonar models, such as the one pictured here, were equipped with autofocus.

Portability

In addition to functionality, portability will have a big impact on your ability to capture spontaneous moments and unexpected beauty.

Consider the camera size and weight that is ideal for you. Will you shoot more if you always have your camera in your purse? Will you carry a camera bag wherever you go? Will you feel safe carrying a big camera around?

Trust me on this: You will not want to miss the perfect shot because you left your camera behind. Choosing a camera that is compatible with your lifestyle is the best guarantee that your camera will always be with you.

Personal Rhythm

Each person sees, feels, and moves differently, and a camera needs to follow the unique way we each show up, position ourselves, and press the shutter.

Some people love the rituals of film photography, such as loading film and waiting for their shots to come back from the lab. Others prefer the freedom of shooting lots of pictures and seeing their shots immediately in digital format. Still others want to watch their instant photos reveal themselves slowly, right in front of their eyes.

Tune into your shooting style and ask yourself what type of camera works at the same speed you do. Sometimes we can get pulled into shooting with a particular camera because of an aesthetic trend, but after a few trials, we lose our motivation and put that camera aside.

While it is fun to play with a variety of camera types, I urge you to stay true to yourself and find at least one camera that is the seamless extension of you and operates in sync with your own rhythm.

Confidence

When you hold a particular camera in your hands, try to notice how it makes you feel. Do you feel intimidated or empowered? Always choose a camera that makes you feel empowered! When you shy away from your own power, you miss the opportunity to fully express your individual point of view.

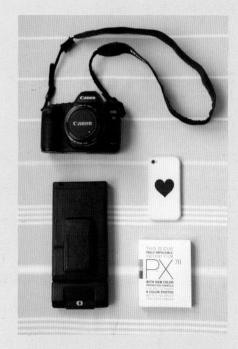

ABOVE: This is my personal camera kit for everyday shooting: 5D Mark II (DSLR), Sonar SX-70 (Polaroid), instant film by the Impossible Project for the SX-70, and my iPhone for casual shots.

Special features

Other factors to look for in cameras are brand reputation, performance, speed, and lens compatibility. I've learned about these features through research and experimentation, and I recommend that you do the same.

Renting is a great, affordable way to experiment with different cameras and to find out what equipment is right for you. You can also read product reviews, participate in online forums, and talk to other photographers to benefit from their insight. But nothing will substitute for your own experimentation. It is only through hands-on experience that you will come to understand your personal needs and preferences.

Please do not get discouraged if it takes you a few trials before you find a camera system that works for you. For many of us photographers, the search for new ways of expressing how we see and feel is a lifelong process, and different tools will be best for different projects and seasons in our lives.

<u>TIP</u>

As you begin your selection process, keep in mind that it is the combination of camera, lens, and film (when applicable) that will affect the final look and feel of your images.

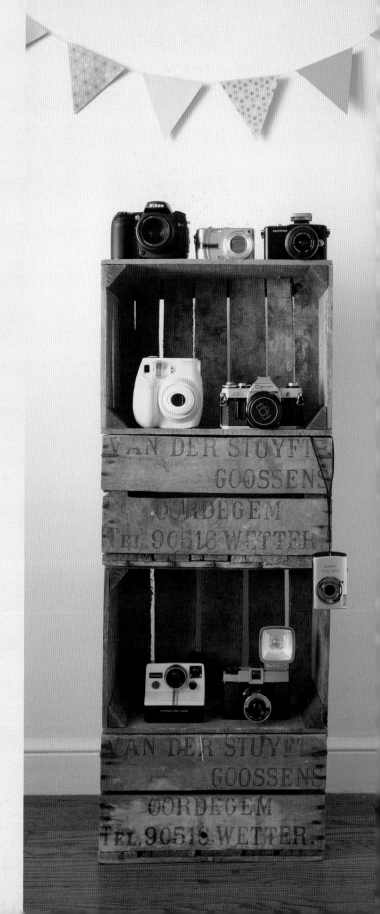

RIGHT: (Left to right; top to bottom) Here are several cameras including a digital SLR, a digital compact camera, an interchangeable lens camera, an Instax, a film camera, a small digital compact, a Polaroid Land Camera, and a Diana toy camera.

A BRIEF OVERVIEW OF CAMERA OPTIONS

Format

Cameras come in essentially four formats that indicate the size and shape of the film or digital sensor used to record the image: miniature, 35mm, medium format, and large format.

Body Type

Smartphone Cameras: Smartphone cameras are increasing in popularity because they are always handy, they offer a variety of filters and effects, and they allow you to easily share your images online. There are limitations in terms of functions and image quality, but if you want to focus mostly on story and **composition**, these cameras might be a fine option for you. Smartphone cameras are in general a great backup option for spontaneous snapshots when your main camera is not with you.

Point-and-Shoot Cameras: Point-and-shoot or compact cameras might be a good choice if you do not have a smartphone or if you want to have a dedicated camera that fits in your bag. Point-and-shoot cameras offer nifty, built-in options for editing and image enhancement, but they are not ideal if you want to shoot outside auto mode. The image quality and features can vary greatly depending on the camera's price range.

MILC (Mirrorless Interchangeable Lens Cameras): MILCs might be a good choice if you want a compact camera that offers interchangeable lenses. They are called *mirrorless* because they do not operate with a mirror-based viewfinder like the SLRs (see below). MILCs usually fit in between a compact camera and a low-end SLR in terms of creative control and image quality.

SLR or DSLR (Single Lens Reflex or Digital Single Lens Reflex): (D)SLRs allow photographers to look through the viewfinder and see an image as if they were looking through the lens. These cameras offer creative control and great image quality, as well as a variety of interchangeable lenses. If you are ready to take your photography to the next level, this type of camera may be right for you. The price tag and learning curve will vary greatly as these cameras can offer low- to high-end features. But the investment is worth it because you will gain higher quality images and avoid frequent upgrades.

Instant Cameras: Instant cameras or Polaroid cameras produce a developed and printed image immediately after exposure. Instant cameras are fairly easy to use, but they offer minimal creative control. Image results depend largely on film quality and your understanding of your camera and film capabilities. Instant cameras are good options for film enthusiasts seeking experimentation, instant gratification, and images with a distinct vintage appeal. Polaroid was the leading brand in instant photography until it announced in 2008 that it would stop its camera and film production to focus on digital equipment. That same year, the Impossible Project was founded by two instant-photography enthusiasts with the mission to keep the art of instant photography alive. The Impossible Project produces film and other materials compatible with Polaroid cameras. You can buy vintage Polaroid cameras through online auctions, estate sales, flea markets, and through the Impossible Project website (see the Resources section for more information). Fuji also produces instant film and the Instax camera series.

Toy Cameras: Toy cameras are simple film cameras, mostly made of plastic, that produce artistic images resulting from unpredictable optical effects such as vignetting, light leaks, and blur. Toy cameras are very affordable and easy to use, but they offer minimal creative control. They are good options for film enthusiasts seeking experimentation and spontaneity. Some of the most well-known toy camera models include the Diana, Holga, and Lomo LC-A. A movement and style of experimental photography called Lomography started in Vienna in the early nineties and was inspired by the Lomo LC-A Russian camera. Lomography is also the name of a company that imports and produces a variety of analog cameras and accessories.

Types of Lenses

"Look and think before opening the shutter. The heart and mind are the true lens of the camera."

—*Yousuf Karsh*

The Hasselblad 500C/M is a medium format camera produced in 1957. This camera uses the incredibly sharp 80mm Zeiss lens.

Prime Lenses: Prime lenses have a fixed **focal length**, so they require you to move closer or farther from your subjects, as opposed to zooming in or out. These lenses usually have great optics and offer terrific image quality. They allow for larger apertures, making them a smart option for low-light situations or for throwing the background out of focus. These lenses can be standard, wide, or medium telephoto.

Zoom Lenses: Zoom lenses allow for a range in **focal length.** These lenses offer photographers more flexibility in how they position themselves in relationship to their subjects. They allow photographers to zoom in or out to get the shot, instead of having to change their physical position. There are standard, ultra-wide, and telephoto zoom lenses.

Macro Lenses: Macro lenses are used for close-up photography with a 1:1 magnification. These types of lenses allow you to get really close when focusing on very small subjects, and they magnify details that cannot be detected by the naked human eye. They are commonly used to photograph insects, flowers, and food.

Wide-Angle Lenses: Wide-angle lenses are most often used in situations where the photographer needs to fit more into frame but cannot move further from it for a wider view. These lenses are recommended for shooting interiors, architecture, and landscapes, but they can also be used in other situations where there is not much distance between the subject and the camera, such as self-portraits taken at arm's

length. Common **focal length** for these lenses is approximately 14mm to 35mm.

Standard or Normal Lenses: While other lenses expand or compress our **field of view**, standard lenses capture the world similar to how our eyes perceive it. Because of their natural results, they are usually recommended for portraiture. **Focal length** for these lenses ranges from 40mm to 50mm, but that can vary depending on the size of the sensor in some DSRLs.

Medium Telephoto Lens: These lenses fall in between the standard and telephoto lenses. Their common **focal length** is approximately 85mm to135mm, which makes them ideal for portraiture.

Telephoto Lenses: These lenses have a narrower **angle of view**, so they magnify and capture details in faraway scenes. They are especially helpful for situations in which the photographer cannot physically get close to his or her subjects. Telephotos also have longer **focal lengths**, so they compress the distance between near and far subjects, making them look closer together. This optical effect reduces the **depth of field** and somewhat flattens the scene, so it needs to be used purposefully to be successful. These lenses are most commonly used for photographing wildlife, but they can also be used for sports, action shots, nature, portraits, and more. **Focal lengths** range from approximately 135mm to 300mm.

Super Telephoto Lenses: These lenses have **focal lengths** that are even longer than 300mm.

Fish Eye Lenses: These lenses are wide-angle lenses that were originally created to photograph the stars in the night sky. They produce wide panoramas with a spherical effect which makes them great lenses for fun and experimentation.

Tilt Shift Lenses: These lenses have nobs that allow you to tilt, shift, and rotate them. These features give you the ability to angle your plane of focus, to alter perspective, and to adjust your shooting angle without having to change your physical position in relationship to your subject. They are also used to miniaturize large subjects, and they can be used to shoot a variety of objects.

Portrait Lenses: Some lenses are considered better choices for portrait photography. Photographers should choose a portrait lens depending on the distance from the subject (a zoom lens can give more flexibility), proportion (if a subject is too close to the lens, it can appear larger—an unflattering effect when certain body parts are exaggerated), how much space is available to shoot (indoor spaces can be tight and allow only a short distance between the photographer and the subject), and the type of portrait in question (environmental, head shot, seated, full body, etc.). Also, lenses with longer **focal lengths** and large apertures are best for throwing the background out of focus and producing great **bokeh** making the subject in the foreground pop.

Understanding Light and Exposure

LIGHT

Light is the single most important ingredient in photography. In fact, the word *photography* comes from the Greek words *photos*, meaning "light," and *graphé*, which means "drawing, which combine to say "drawing with light."

There are three types of lighting: natural, artificial, and a combination of both. Natural light is provided by nature, such as sunlight, moonlight, and starlight. Artificial light is the lighting provided by man-made light sources, such as incandescent (tungsten or tungsten halogen lights, used as household bulbs and "hot studio lights"), fluorescent (light tubes often found in offices), sodium vapor (used in streetlights), neon (colored lights used in signs), LED (light panels), and flash (**on-camera flashes** and **studio strobes**).

For the sake of shooting with soul, we will focus on natural light, but you will also find tips throughout this book on how to make the best of common artificial lighting scenarios.

Learning to see light and understand light in all its nuances is an essential skill for capturing images that are beautiful and moving. When assessing the light, there are several attributes to consider.

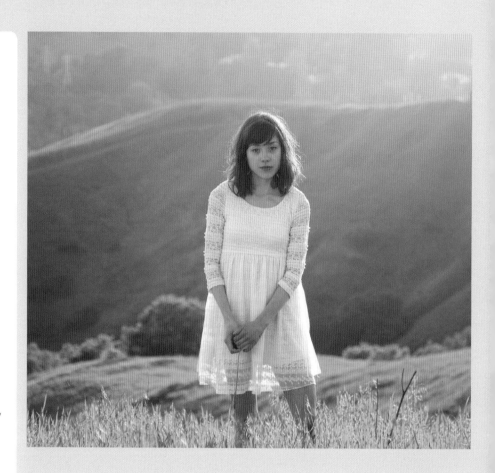

"Light makes photography. Embrace light. Admire it. Love it. But above all, know light. Know it for all you are worth, and you will know the key to photography."

—George Eastman

Direction

Before you photograph anything, you must first ask:

Where is the light coming from?

By evaluating the direction of the light, you can better decide how to position yourself in relation to your subject.

Front Light: Sunrises, sunsets, and **camera flashes** are the most common sources of front light. At low intensities (late in the day or diffused), front lighting can be good for capturing evenly lit scenes or for capturing subjects that benefit from having fewer shadows. However, you must be selective in how you use front lighting as it can also produce images that are flat, lack detail, and have no depth. When shooting portraits, bright front lighting (sunlight) can also cause your subjects to squint. In addition, camera flashes usually have a short range and can produce images of great disparity, with very bright subjects against very dark backgrounds.

Sidelight: Sidelighting is when the main light is coming from either side of the subject. This type of lighting creates shadows and adds contrast to the scene. It is great for emphasizing textures and conveying depth. But, depending on the subject and scene, this type of lighting may benefit from an additional **fill light** or a **bounce** to brighten up the shadow areas.

Back Light: When the main light source is behind the subject, it is called back light. This is my favorite type of light!

Backlighting can be challenging, but it is effective for producing images that are dreamy and magical. A light coming from behind the subject can create a halo or glowing effect and often produces **lens flares**. In order to avoid images that are too dark in the foreground, you need to adjust your camera settings (ISO, aperture, and shutter speed; see the Exposure section), add a **fill light**, or **bounce** some light back at the scene with a **reflector**. You can also take advantage of the contrast between the bright background and the dark foreground by capturing interesting **silhouettes** that emphasize shape and form.

Quality

Besides direction, you should take note of the quality of the light and how it affects the subject. The light can have a hard or a soft quality.

A light is considered hard or soft depending on the size of the light source and the distance between the light source and the subject.

Although the sun is the biggest light source of all, its great distance from the Earth makes it relatively small in the sky. Therefore, it is a small light and a hard light source, casting strong shadows on subjects for most of the day. When the sun is the closest to the horizon at sunrise or sunset, or when it is filtered by clouds, fog, or trees, it is considered soft light.

Hard Light: Hard light is typically what you find on a sunny day around noon. It is direct, intense, and spectacular, and it creates strong and sharp shadows. Although not recommended for most types of photography, hard light can be used to create drama and to produce stylized effects.

Soft Light: Soft light is found in the early morning and late afternoon, on cloudy or foggy days, under trees, and in open shade areas. This type of light is broad, filtered, and diffused. Soft light is more interesting to photograph because it is lower in contrast and offers a wider range of tones and shades. This is a desirable light quality for portraits because the subjects are usually more evenly lit.

Color

Light changes dramatically over the course of the day and depending on weather conditions.

In the first few hours of the day, the color and intensity of daylight changes quickly. You will notice that just before dawn, the light is cooler. Then pinks and reds are introduced. Later, when the sun rises, the light becomes progressively warmer and more golden. At the end of the day, the light changes dramatically once again, shifting from warm sunset tones to cooler blues and purples at twilight.

"In the right light, at the right time, everything is extraordinary." —Aaron Rose

EXPOSURE

Exposure is a fancy word to describe how much light is allowed to reach the film or the camera sensor when you are taking a photograph. Too much light results in a very bright and overexposed image, while not enough light results in a very dark and underexposed image.

There are three settings that determine exposure: aperture, shutter speed, and ISO.

Aperture: The aperture setting controls the opening in the lens and, therefore, how much light gets in. The aperture setting is indicated by an **f-number**. A large opening in the lens will result in more light reaching the film or the sensor. This concept is easy to understand since a large hole lets in more light. The tricky thing is to remember that a large aperture is indicated by a small **f-number**: f/1.2, f/1.4, f/1.8, f/2, and f/2.8. Although this is counterintuitive, a small **f-number** equals more light. The aperture setting also controls the depth of field. Another tricky thing to remember: A large aperture setting equals a smaller or shallower depth of field. In other words, a small **f-number** will create a blurrier background.

Shutter Speed: The shutter speed setting determines how long the **camera shutter** stays open. If the **shutter** stays open for a long time, more light reaches the film or the sensor and vice versa. The shutter speed is indicated by fractions of seconds (1/125, 1/500, 1/1000, etc.). Some cameras do not show the fraction, so you have to remember, for instance, that a shutter speed of 60 (or 1/60th of a second) is slower than 1000 (or 1/1000th of a second). The shutter speed will also control how you capture action in your shots. A faster shutter speed will freeze action while a slower shutter speed will capture the movement (usually blurring the action).

ISO: The ISO system measures the "film speed," which is the film's or the camera sensor's sensitivity to light. The ISO is indicated by numbers such as 100, 200, 400, 800, etc. The higher the number, the faster and more sensitive the film or camera sensor is to light. On a sunny day with lots of available light, you will want to use a slower film or a setting of low ISO (100 or 200) to avoid overexposing the image. On overcast days or in open shade, you will want to use a faster film or medium ISO (400), and for low-light situations, a high speed film or high ISO (800 or higher). Keep in mind that the slower the film and lower the ISO, the finer the **grain**, the more detail, and the higher the image resolution in the processed image. Consequently, a faster film or higher ISO image will have larger **grain**, lower resolution, and more noise.

Now that you know each of the possible settings, you can shoot in **manual mode** and better control the look of your images. By balancing aperture, shutter speed, and ISO, you will be able to achieve a particular exposure.

Each person has his or her own method for working out the exposure. I start by setting my ISO based on the available lighting conditions (either by buying a certain film or by adjusting my ISO setting in the digital camera). To determine my next setting, I think about whether the shot is about capturing action or **depth of field**. For instance, if I want to shoot a still image with a shallow **depth of field**, I will set a large aperture. This means that the lens will be wide open and lots of light will get in. In order to avoid overexposing the image, I will then choose a faster shutter speed so that the **camera shutter** stays open for a very short fraction of time and less light is allowed to reach the film or camera sensor.

Most instant cameras and toy cameras do not offer all these settings, but they might offer an exposure dial or an ISO dial for you to lighten or darken your images depending on the lighting conditions.

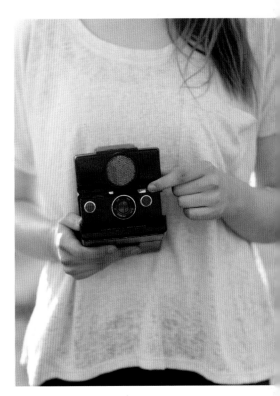

On some instant and toy cameras, you can dial your exposure by adjusting a brightness wheel.

Learning to See Life through the Viewfinder

The biggest challenge for photographers is to translate the beauty that they see, as they see it, into photographs.

I often hear from students and peers that their image did not turn out as expected or that they were not able to capture the essence and the magnificence of what they originally saw.

This is an ongoing challenge for me as well, but I believe that there are four main factors that separate a snapshot from a great photograph: the photographer's eye, the photographer's thought process, the photographer's soul, and the photographer's knowledge of his or her camera.

Anybody can take a picture. But in order to make an image that you and others will love, you need to follow a magic recipe:
(See) + (Think) + (Feel/ Connect) + (Shoot) = Great Image

Sounds simple? It is! But as with any formula, the challenge lies in the execution.

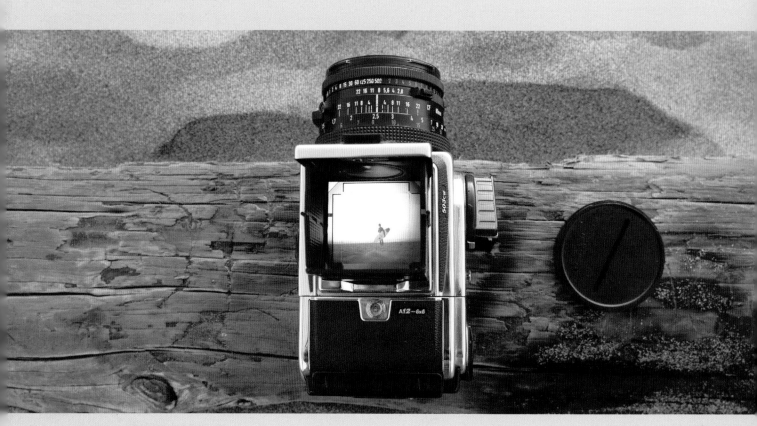

Looking down at the viewfinder instead of at eye level can be a helpful tactic when the photographer wants to be discreet.

LEARNING TO SEE

In the previous section, you learned how to **see** your subjects under various types of light. Now I'm going to list a few points to consider when you look through the viewfinder. Before you press the shutter, *think* about why and how you are going to take the picture.

Purpose: When something grabs your attention, take a moment to notice what you are seeing, feeling, and experiencing. Think about what you want to communicate and what reaction you want others to have when they see the photograph you are about to take.

Main Subject: Think about your main subject and how you want to draw attention to your image. Decide where you want to focus on. Look for any distracting elements that will compete with your subject and study how you will remove or minimize them in the frame.

Depth of Field: Consider having a shallow **depth of field** to better separate your subject from the background. Depending on your camera, the **depth** of field can be adjusted by selecting **portrait mode**, by adjusting aperture settings, or by increasing the distance between the subject and the background. Depending on your lens, you can also achieve this by increasing your distance from your subject and by zooming in from afar.

Light: As discussed in Understanding Light and Exposure, notice where the light is coming from. Decide how you will position yourself in relationship to the light and to your subject.

Point of View: Think about how you want the camera to look at the scene. Decide what angle and perspective will be best for telling your story.

Composition: Assess the elements of your scene and think about your options for composing the shot.

1. Think about whether you want to apply or break the **rule of thirds**.
2. Note if there are any interesting elements that you want to emphasize, such as color, textures, **patterns**, or **symmetry**.

3. Look for **framing** elements that can be used to make a stronger picture, such as tunnels, archways, window frames, or doorways.
4. Study how to use **leading** or **converging lines** to draw the eye into the picture and to create a sense of depth.
5. Consider zooming in or moving closer to your subject.
6. Unless you are shooting a square image, think about whether shooting vertically or horizontally will work best for that particular scene.

Action: Evaluate posing and movement. Decide if the shot is about a particular pose, if you want to show motion, or if you want to freeze the action. Frame your shot accordingly.

Settings: Take a moment to double-check your camera settings and adjust as needed before you shoot.

The more you practice these steps, the faster and more intuitive your process will become, leaving you time to focus on expressing your soul.

THE RULE OF THIRDS:

Imagine that your image is divided into thirds by two vertical lines and two horizontal lines in each direction, with nine parts—like a tic-tac-toe game. The rule of thirds is a principle based on the idea that images are more interesting when the main subject is placed near or where these imaginary lines intersect.

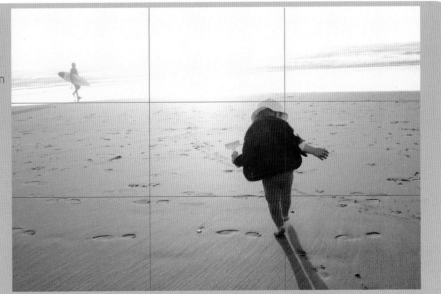

Shooting with Soul

In a world full of incredible art as well as marketing images blasting from websites, TVs, and billboards, it is common to feel overwhelmed when trying to shoot fresh and original material. But in order to produce work that is truly unique, you must be in full alignment with your soul.

Now that you have mastered how to *see* and *think* during your photo taking process, I'm going to share with you some tips to help you *feel* and **connect** with your subjects on a soul level.

"When we shoot with greater awareness and intention, we extend the gift of our unique experiences to others."

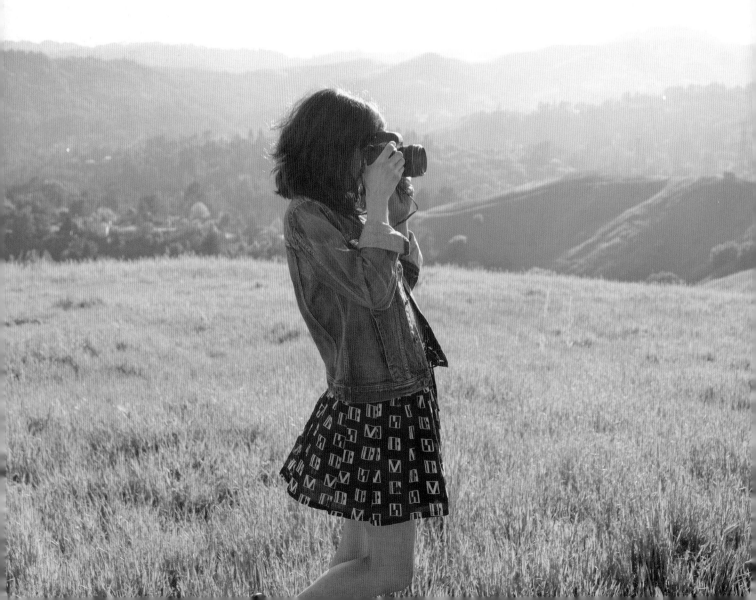

Here are five steps that are at the heart of soulful shooting:

Slow down and think.

Slowing down is the first step to *feeling* and *connecting*. If there is one piece of advice that I hope you to take away from this book, it is to "slow down and think" before you press the **shutter**. I firmly believe that there is no such thing as a good image that was taken in a hurry. This book is about calling on your soul and trusting your intuition, but that requires you to pause and to reflect on your intention and vision.

As you gain confidence and become proficient with your equipment, you will get faster at executing your shots. But even then, you will need time to process your emotions and ideas before you can express them.

Take in the environment using all your senses.

Most of us have the impulse to snap quickly without carefully considering what we are feeling in the moment and how we wish to communicate those feelings in our photos.

When something catches your eye and you decide to take a photo, ask yourself, "Why do I *feel* moved in this moment?"

Light, colors, textures, shapes, sounds, and smells activate our emotions and inform our experiences. Take a deep breath. Listen closely. Stare. Touch. What are you responding to?

Use the camera as a pen.

A few years ago, I watched a documentary about the acclaimed photographer Bill Cunningham that really struck a chord with me. In the film, Cunningham mentions that he acquired his first camera from a photographer friend who handed it to him and said, "Here. Use it like a pen. You take notes; do it with a camera."

I've noticed that shooting is indeed more intentional and soulful when it is approached as if we were taking notes on life. The idea of creating a record of some sort helps us create a connection between what we *see*, *think*, *feel*, and want to express.

Since most of us are accustomed to journaling on paper, some of the photography exercises in this book come with writing suggestions to help get your ideas flowing before you begin shooting. The more you practice taking visual notes, the more intuitive it will be for you to express your vision using the camera as your main tool.

The camera looks both ways.

The camera sees us photographers as much as it sees our subjects. It sees our point of view, our reactions, and our emotions. It sees our souls.

It is a wonderful practice to study your photographs to see what messages you are communicating and how much of your essence is coming across. For instance, I find it interesting that in the photos that I take of my very active daughter, she often comes across as very contemplative, which is actually a quality of my own spirit and shooting style.

Knowing how the photographer impacts a photograph can also be a helpful insight when shooting in stressful situations. In those instances, the photographer must find ways to separate from the difficult situation in order to project the right kind of energy onto the photos.

Get to know your subject.

Artists create their most impressive work when they draw inspiration from what they know best. That is because we can only express our soul when we feel a connection with our subject matter.

When starting out, this tends to be easiest to achieve with photographs of your family members and friends. But as you venture out to explore new subjects, places, and themes, you will need to strengthen your connection to what you are shooting by doing some research. Learning about your subjects will promote a level of bonding and understanding that will resonate for you on a soulful level and that will consequently come through in your photographs.

"Remember that the camera looks both ways. In picturing the subject, you are also picturing a part of yourself. You are a mirror." —Rick Sammons, Face to Face.

You: Discovering who you are

Exercise 1: Glimpses of you

INSTRUCTIONS

1. You can feature your whole self or simply one body part.
2. Use the background and lighting condition to set the mood.
3. Use wardrobe and props to highlight your personality.

TECHNIQUES

• Use a **tripod** to stabilize the camera and lock its position. You can also prop the camera onto a stable surface.

• Use a stand-in to mark your position while you compose and focus the shot.

Depending on your camera:

• Use a self-timer to delay the trigger while you get in position or use a remote to trigger the shutter while standing several feet from your camera.

SHOT IDEAS

• Photograph your feet. Tell the story of where you have been and where you were standing.

• Take a picture of your hands. Hold something meaningful, show the texture of your skin, or feature meaningful jewelry.

• Photograph a glimpse of your body covered by an interesting shadow.

Photographing little glimpses of yourself is a great way to reveal just enough of your identity while leaving a lot up to your audience's imagination.

There is a world within you. You have thoughts, memories, and longings. You have all the places you have visited, the people you have met, and the things you have done. You carry all these stories in your body as much as in your heart and mind. Focus on the parts of you that are holding on to these stories. What do we see when we look into your eyes? What are your arms longing to embrace? Where have your feet traveled?

While most of us feel vulnerable in front of the camera, I invite you to approach this exercise with curiosity and an open mind. Look beyond the surface. This is not about appearance or perfection. Dig deeper and ask yourself: Who am I? How do I feel? What do I want to express?

This shot captures the reflective and romantic nature of my personality. I also like how it shows my freckles because they remind me of my teen-age years spent on the beach in Brazil. Try to set the appropriate mood for your photo. Capture details that are meaningful and tell a story.

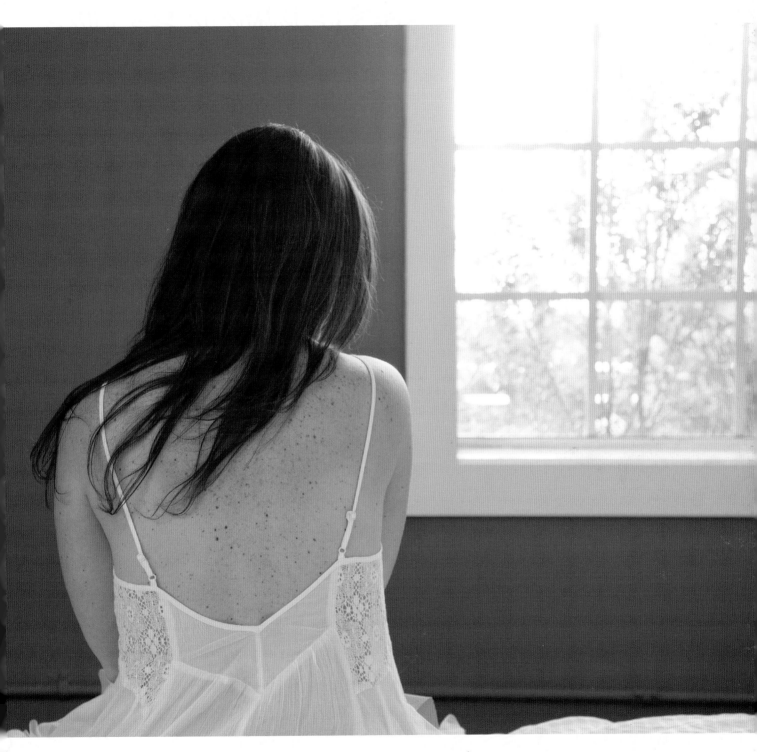

"Think . . . of the world you carry within you." — *Rainer Maria Rilke*

Exercise 2:
Your reflection

Whether we are exploring the wilderness, visiting a new city, or sitting in our own couch at home, we can create evidence of our presence in the world by shooting self-portraits that incorporate our reflections.

Reflective surfaces are everywhere. At any given time, our image is being reflected in windows and mirrors, but it also emerges in the most unexpected places, such as utensils, light fixtures, or sunglasses.

For this exercise, I invite you to select a location that you are drawn to for whatever reason. Scan your environment in search of mirrors, windows, television screens, computer monitors, glossy walls, lustrous floors, shiny objects, metallic details, and liquid surfaces. Once you find your reflection, look through the **viewfinder** and move around until you and your surroundings are composed in an interesting way. Pause. Before you press the shutter, enjoy a moment of stillness. Acknowledge yourself in that moment and image. Then shoot your reflection and create long-lasting proof that you were in that space.

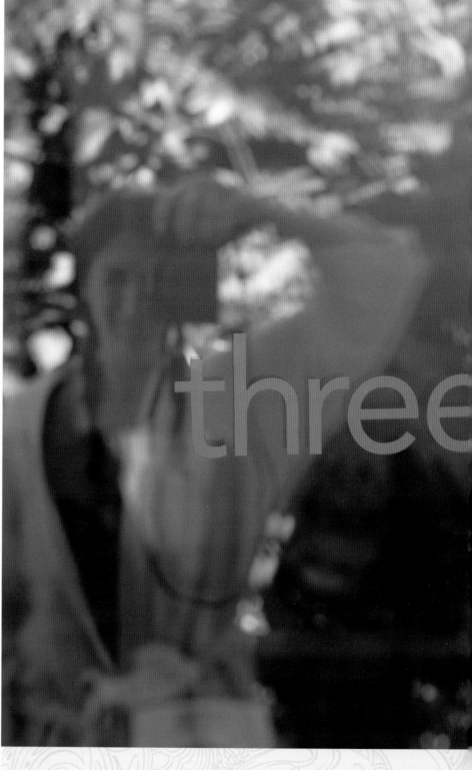

"Zen masters say you cannot see your reflection in running water, only in still water." —Elizabeth Gilbert

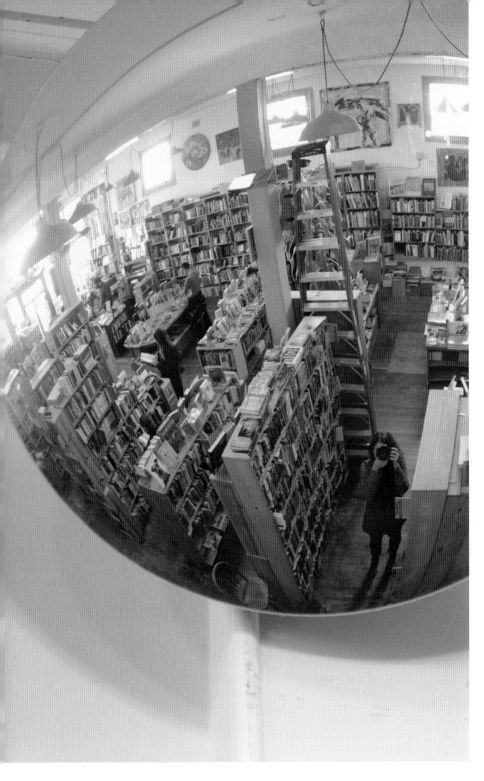

INSTRUCTIONS

1. Go on a photo walk and push your creative edge by finding serendipitous reflections along the way.

2. Document where you were and what you were feeling at that moment.

3. Play with **distortions**, optical illusions, unusual perspectives, and textures.

TECHNIQUES

Depending on your camera:

- Turn off your **flash**! Otherwise, you will see the flashing light in the shot.

- Shoot with a small aperture to have both the reflection and the environment in focus.

- Shoot with a **fish-eye lens** or a **Lensbaby** to add fun **distortion effects** to your reflection.

SHOT IDEAS

- Shoot a partial reflection showing only a detail of your body.

- Move the camera away from your face for a variation. Shoot from the waist level.

- Capture your reflection on a puddle.

LEFT: I took this photo on our first trip as a family, when my daughter turned one year old. When I realized we were staying in room number three, I decided to take this shot to remember the significance of our first vacation together as a family of "three." Use your reflection to capture the meaning of your presence in a particular time and place.

ABOVE: Mirrors are some of the most common reflective surfaces, but when they are found in unusual places or reflect an interesting location, they can inspire unexpected and clever shots.

Exercise 3: Your shadow

Shooting your own shadow is another great way to express your personality and creativity. Shadow shots appeal to even the shiest photographers and offer numerous opportunities for artful concepts and **compositions**. You can use your shadow to document the seasons, to indicate the places you have been, and to showcase things that you have seen or found in your adventures.

While the results are often mysterious and intriguing, the process of shooting your own shadow is simple, fun, and lighthearted. All you need is a bright light source and an interesting background on which to cast your shadow. Although shooting outside is the most common situation for shadow shots, you can shoot indoors as well. If you want to shoot inside, look for a place with a strong light source, such as the light from a window, a candle, or a lamp.

RIGHT: Take advantage of a textured background and leading lines to create a dynamic shadow shot. While the shadow directs the eye from the bottom to the top of frame and the horizon line leads the eye from left to right, the patterns in the sand work as diagonal lines, making the eye travel across the image. In addition, the sea foam at the bottom of frame helps tie the entire image together by leading the eye to the top right corner of frame.

FAR RIGHT: The leading lines and the elements in the background add interest to the shadow. The curvy diagonal lines of the pool lead the eye across the shadow from bottom right to top left. The "click" element on the top right side is of less visual weight than the shadow, but it brings the eye back to that corner of the frame and contributes to a more balanced image overall.

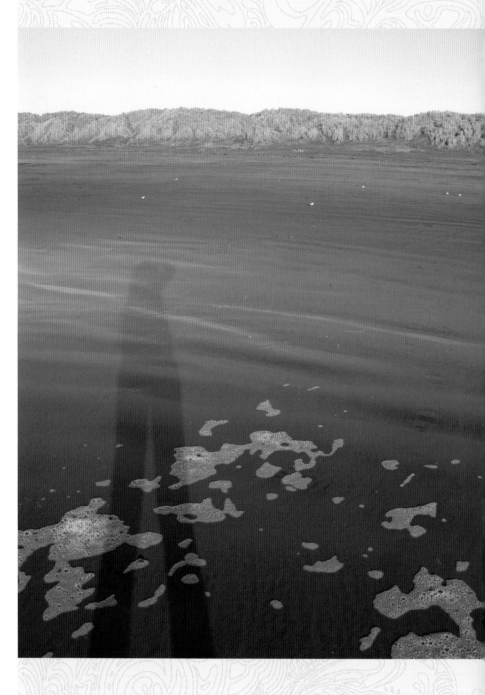

"There is strong shadow where there is much light." — Johann Wolfgang von Goethe

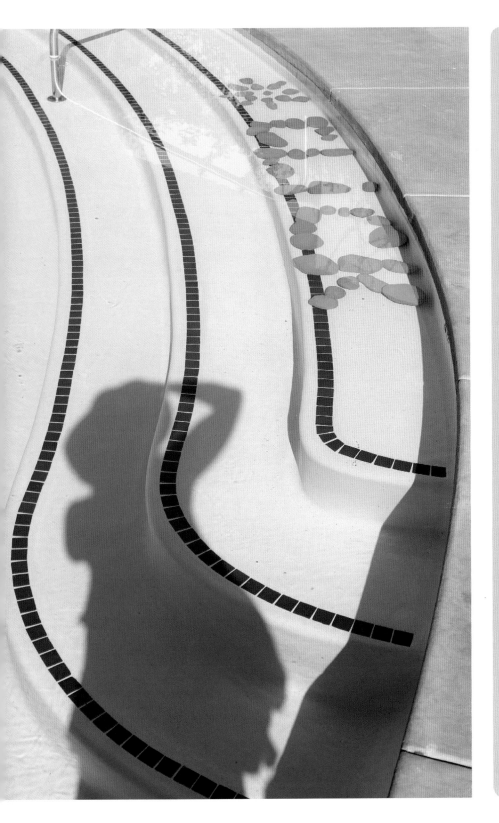

INSTRUCTIONS

1. Find an interesting location to capture your shadow.

2. Choose a light-colored, clean background for better contrast with your shadow.

3. Play with architectural lines, color, interesting surfaces, **patterns**, and textures.

4. Observe the light. When the sun is very low in the sky—either in the early morning or the late afternoon—you will cast more interesting, softer, and longer shadows. Around midday, when the sun is directly overhead, your shadows will be harder and shorter.

TECHNIQUES

- Turn off your **flash**. You need the contrast between the light and dark when capturing interesting shadows.

- Use a **tripod** or prop the camera on a secure surface to free your hands and body for interesting posing.

- Use a self-timer or remote so you can jump, wave, etc. (Hint: Your **tripod** will most likely also show up in the photo unless you can place it behind or away from the light source.)

SHOT IDEAS

- For an interesting variation, photograph your shadow cast onto a wall instead of on the ground.

- Take a picture of your shadow with an interesting or unusual pose.

- Interact with your environment: Take a photo of a shadow of you touching, holding, or pointing at something around you.

Exercise 4:
Something you collect

There are numerous reasons why people collect. Some are interested in preserving memories and history, others are in search of the beautiful, odd, and rare, and still others are motivated by value and investment. But despite the specifics, every collection tells a story about the collector and its contents, making collections fascinating subjects to photograph.

A photograph that reveals a frivolous habit or an obsession of sorts can be very intriguing. And who doesn't love having a peek into someone else's life, especially when they discover an eccentric edge, a secret, or an endearing fact?

For this exercise, assemble and shoot a collection of your own treasured items. If you do not have an obvious collection, you can gather some of your belongings based on a theme. For instance, you can group old photos, journals, letters, and books. Anything goes as long as it tells a story about you and your personality.

This image uses several leading lines, shapes, and colors to draw the viewer's eye to the main focus. Notice how the legs and arms are positioned, creating triangles that lead the eye to a converging point in the center of the frame. The position of the head and the arch created by the shoulder line also help bring the viewer's eye down to the hands filled with sea glass. Finally, the overall color and tones are neutral and muted, which makes the colorful sea glass stand out.

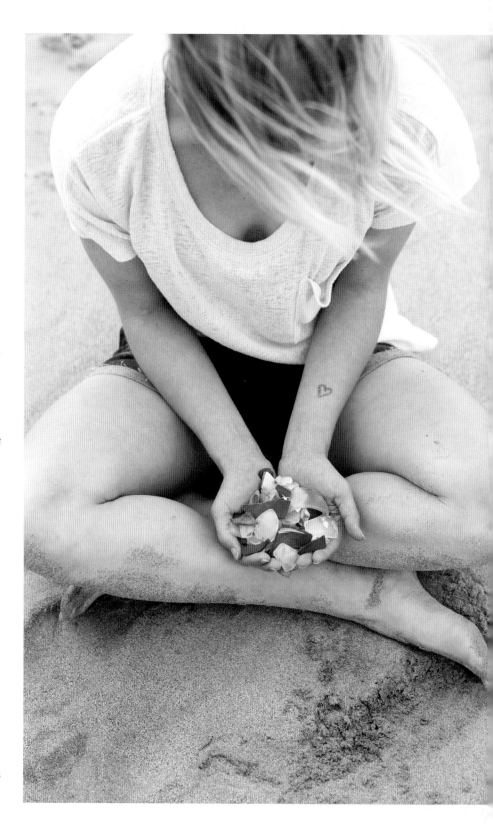

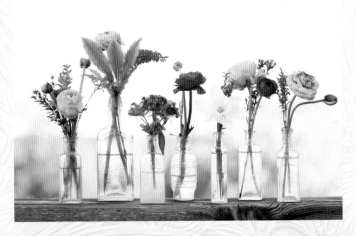

TOP: This shot uses backlighting to highlight the color, transparency, and details in the vintage bottles. Assess what type of lighting will work best to enhance the special characteristics of your collection items.

BOTTOM: Here the color and shallow depth of field help create impact and separate the collection items from the background. Identify the main assets of your collectibles, and decide which photo techniques can be used to emphasize them.

INSTRUCTIONS

1. Photograph your collection either as an organized or a spontaneous arrangement. Experiment with styling to see what works best for your collection.

2. If you are photographing multiple objects, throw in a surprise element, such as an item with an odd shape or a different color to make your shot more interesting.

3. Overhead shots are typically used for organized collections, but you might want to experiment with other approaches. Shoot straight on or at an angle.

TECHNIQUES

- If your collectibles are stored inside plastic sleeves, avoid reflections by shooting without a **flash**. For even better results, remove the sleeves. The same applies if your collection is framed behind glass. Remove the glass from the frame to avoid reflections.

- When shooting reflective subjects such as silver jewelry, items made from metal, or glass ornaments, shoot at an angle to avoid reflections.

- If possible, use a **tripod** to keep the camera in place while you style the shot. You will want to move objects around until you find the best balance within the frame.

- Make sure all elements are in focus.

SHOT IDEAS

- Photograph your shoes, hats, ties, belts, magazines, records, etc.

- A collection doesn't need to have just one type of object. For instance, you could assemble and photograph an eclectic collection of favorite things: a book, a pin, a photograph, a postcard, and a feather.

- Start and photograph your very first collection! All you need is a minimum of three interesting items grouped together.

"Her umbrella was filled with rain she had collected in her travels & on hot summer days she would open it up for the neighborhood kids & we would splash in the puddles & then it would smell like Nairobi or Tasmania ..." —StoryPeople

Exercise 5: Books

We can tell a lot about someone by the books they read. Books that we have read are portals into our past, showing the history of our interests. The books that we are reading are bridges into our future, showing our current hobbies, our aspirations, and our concerns.

My books reveal a lot about my passions and pursuits. Most of them are about art, writing, and the creative process, followed by a good number of photography books, books on décor, poetry collections, travel guides and travelogues, and books about spirituality. I also own books on business, some authored by friends, and finally, a small collection of well-crafted novels and memoirs. On my nightstand, you'll find a quick snapshot of my life at the moment, including a couple of my current favorite photography books, Poetry by Hafiz and Mary Oliver, a book on motherhood by Karen Mazen Miller, and a few children's books that I read with my daughter every morning.

Think about which books have been feeding your soul and imagination lately. What do your books say about you and your life? Photograph your book selection with the intent of sharing a piece of your heart and soul.

BELOW: The lacey background and the high contrast of light and dark set a romantic mood that suits a poetry book. Think about how you can create the right mood for the genre of the book you are photographing.

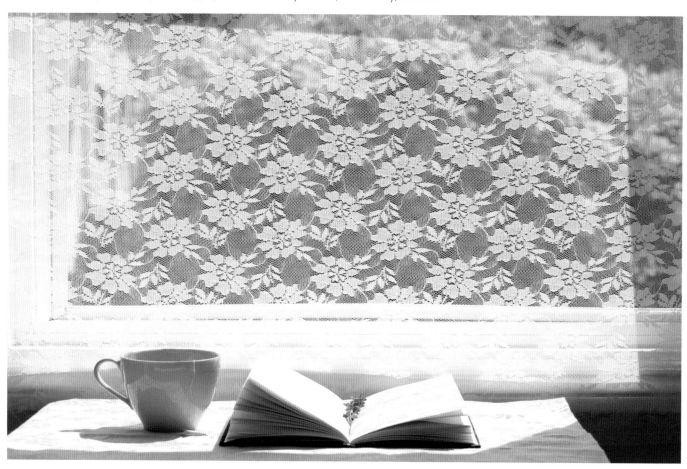

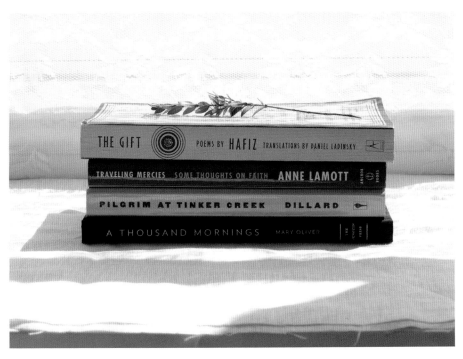

INSTRUCTIONS

1. Stack, arrange, and display your books in an interesting way.

2. Use props to add mood to your images.

3. Assess how the lighting can add mood to your images.

TECHNIQUES

- Use a shallow **depth of field** to highlight details on book cover or pages, or to create depth and separate books from background.

- When shooting the inside pages of a book, make sure you shield the book from direct and harsh light to avoid overexposing the white of the pages.

SHOT IDEAS

- Lay open a book and shoot a quote you love.

- Hold a book that's a current favorite in your hands as part of a self-portrait.

- Shoot your nightstand from different perspectives or shoot your books somewhere other than on your nightstand.

"Books are the mirrors of the soul."

—*Virginia Woolf*

TOP: While still very subdued, the surface textures and the contrast in lighting help to add interest to an otherwise very muted, plain white background. Consider how to create an interesting background that supports your main subject, instead of one that is merely dull or competes with it.

BOTTOM: Even though your books are the main interest for this exercise, take all the elements of the shot into consideration. Here the lighting, the textures, and the patterns in the background help create a poetic atmosphere. The white and gray tones are neutral and help the eye stay focused on the bright yellow cover, and the warm tone of the tea helps tie the image together as the eye travels from left to right.

Exercise 6: Wardrobe and style

BELOW: In this shot, the horizontal lines on the wall and floors complement the styling of the shoes, which are arranged together and lined up side by side. Think about how your background can influence how you arrange and style your items and vice versa.

OPPOSITE: The rustic wardrobe complements the style of the Mexican-inspired dress. Choose elements by keeping a similar theme and style in mind.

One of the most expressive ways to show your personality is through your wardrobe choices. You don't have to be a fashionista to express yourself through your clothes. Even if you tend to shop for comfort and functionality, what you wear communicates your taste and your values.

I find it very amusing when I look in my closet and find clothes that are just wrong for me. There are some items that have somehow made their way into my life even though they do not fit me properly and completely contradict my style. While writing and shooting this book, I have developed an even greater awareness of what I love, of what inspires me, and how I wish to express my style. I now make an effort to purchase and keep those items that make me feel good and that align with my soul.

For this exercise, take a moment to look through your closet and select a few items that represent your truest self. Being able to edit yourself is a valuable skill to have in life and in photography as well. Finding the right balance between what to include and what to leave out of the frame will really help you hone in your style and artistic point of view.

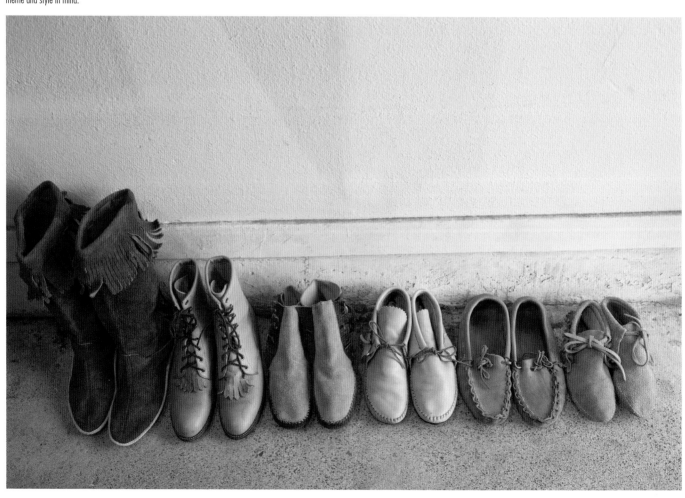

> *"My mission in life is not merely to survive, but to thrive; and to do so with some passion, some compassion, some humor, and some style."*
>
> —Maya Angelou

INSTRUCTIONS

1. Display your favorite articles of clothing and style, indoors or outdoors.
2. You can showcase items on the wall, on the floor, on your bed, or by wearing them.
3. Choose a background the complements the style of the items displayed.

TECHNIQUES

- Clothes, shoes, and jewelry look best in pictures when they are tidy and fit properly. Make sure you prep your items in advance by steaming, ironing, polishing, positioning, removing or obscuring tags, etc.

- Notice how the lighting will affect texture. The stronger the light, the harder the shadows and therefore, the more pronounced wrinkles and folds. Soft, diffused lighting works best.

- When shooting articles of clothing, styling is everything. You may want to use tissue paper or another type of filling to perk up your items, as well as pins to keep certain sections in place.

SHOT IDEAS:

- Photograph one favorite item that represents your style. A single item on a clean or interesting background is enough to tell a story about style.

- Don't limit yourself to items of clothing. Photograph watches, wallets, briefcases, shoes, etc.

- Take a picture of your items hanging on a tree, an outdoor clothes line, or draped over a fence.

Exercise 7: What is in your bag?

Have you noticed that the things we carry around in our bags can tell a good deal about our lives? We carry wallets, receipts, and lip balm. We carry keys, pens, and bills. We carry sunglasses and reading glasses. We carry our phones, cameras, and books. We carry journals, photos, and the occasional phone number scribbled on a napkin. From the most obvious to the most unexpected, each thing we carry holds a story, an idea, and a feeling. These pieces of ourselves ground us in the present time. They are a statement of who we are and how we live our lives.

This assignment is about unpacking your bag on any given day or if you prefer, on a particular occasion that has special meaning to you. Tell us your story by showing what you are carrying in your bag (and in your life).

Work with styling and scale to create a harmonious and balanced shot. The items featured in this image are of various sizes, yet they are styled in a way that gives each item the same visual weight within the composition. The strap of the purse has a curve that helps the eye travel from left to right.

INSTRUCTIONS

1. Select some of the items you carry in your bag and lay them on a surface.

2. You may want to include the bag in your shot. Bags can show style, season, and function.

3. Include items that show an interesting or quirky aspect of your personality. Coveted, unusual, or unexpected items contribute to stronger images.

4. Achieve an interesting **composition** by working with diagonals, perspective, colors, and **shapes**.

TECHNIQUES

• If you like the look of overhead shots, consider using a **tripod** and a **tripod arm**. The **tripod arm** will create distance between the **tripod** body and the camera, and will prevent the **tripod legs** from showing up in the photo.

SHOT IDEAS

• Photograph items from your camera bag, with or without the bag itself.

• Photograph your child's back-to-school backpack.

• Photograph your suitcase—with some of the contents—before or after a trip.

"That day I carried the dream around like a full glass of water, moving gracefully so I would not lose any of it."

—Miranda July

Exercise 8: Home

INSTRUCTIONS

1. Photograph your home at its best when it is clean and orderly.

2. Try another shot when things are messy and real.

3. Which version resonates more with the way you would like to remember it?

4. If you are shooting indoors, try to shoot by a window and introduce as much natural light as possible.

TECHNIQUES

Depending on your camera:

- Use a fast **prime lens** set at a large aperture to get close and capture the details that make your life at home special and memorable.

- Use a **wide lens** to fit in more detail into your images and make your rooms look larger.

- Use a **tripod** in low-light situations.

SHOT IDEAS

- Photograph your home in action: family gatherings, playtime with your kids, meals, etc.

- Capture a favorite corner.

- Take a photo of the outside of your home.

The definition of home may be different for each one of us, but its core meaning is universal. Home is that place where we are always welcomed back. It is where we feel ever comforted, connected, and nurtured.

I moved away from my home and my family in my early twenties. After living abroad for almost twenty years, I feel that I have two homes now, one in Brazil and one in the United States. My home in Brazil smells like fresh mangos and salty ocean breeze. It is the place where everyone has great stories, big hearts, really loud voices, and even louder laughs. It is where my mom bakes cakes, knits scarves, and sews the holes in my socks. It is the one place where I feel completely understood, loved, and safe, no matter what. My home abroad has taken many forms over the years. My home today is in the arms of my husband and in the giggles of my daughter. It is a place to create new memories, traditions, and gather with our family and our friends.

Whether you associate the concept of home with a person, a location, or a feeling, the place you call home says a lot about your heart, your values, and your backstory. For this exercise, I invite you to write out all the words that come to your mind when you think of home. Once you have a good list, look for a thread and select a few ideas to shoot. For example: my kids, my husband, my bed, my pottery collection, freshly baked cookies, my dog, a comfy reading chair, and my favorite coffee mug.

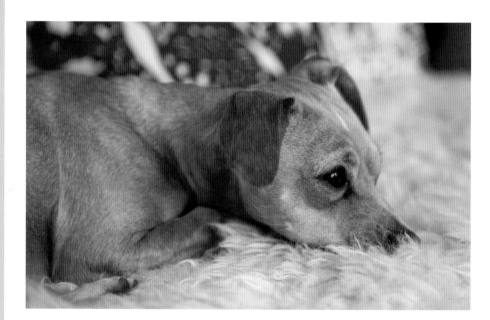

ABOVE: For many of us, home is where our beloved pets rest and play with us. This shot captures a fleeting moment at home by combining a cozy pose, warm tones, and soft textures.

RIGHT: The soft light coming from the window is used to highlight the wrinkles in the pillows and communicate the idea of a comfortable reading nook. Consider how lighting can help inform the feelings you want to express.

"There is no place like home." — L. Frank Baum

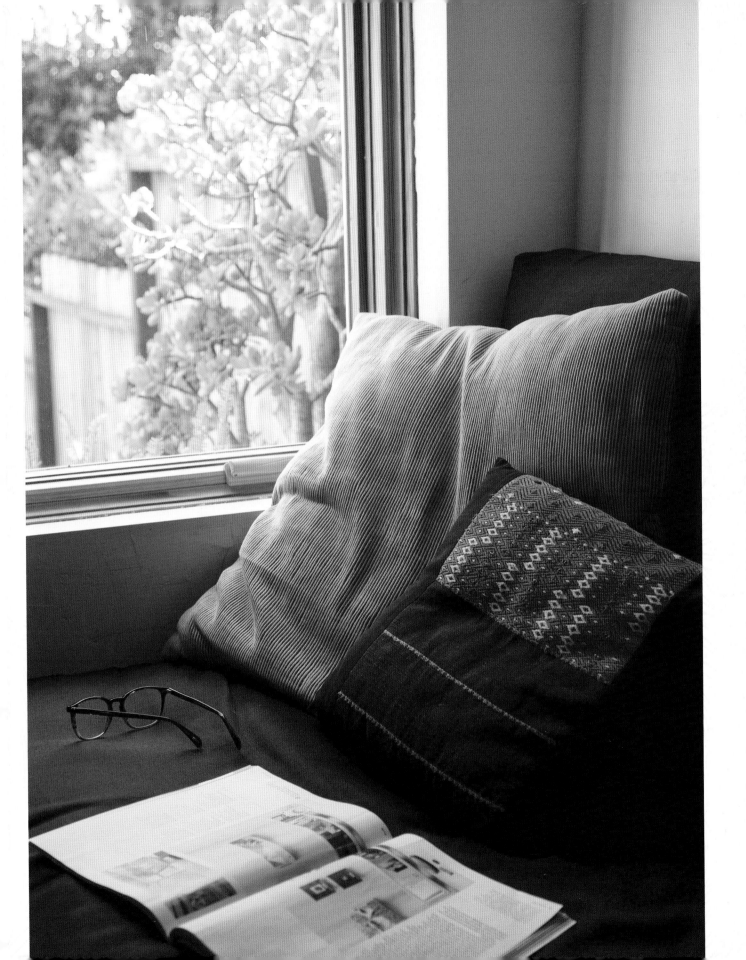

Exercise 9: What inspires you?

Combine black-and-white with color clippings to create contrast within your inspiration board and photos.

Inspiration is the energy that moves through us when we align our souls with the divine. It opens our imagination and fuels our minds with new ideas. Inspiration is the rush that motivates action, creation, and innovation. It is the magic that happens when we tune into our surroundings and breathe in its beauty. It is the drive we feel to distill life's brilliance and turn it into our own expressive art.

Photography helps me live an inspired life. Everything I see, read, and experience inspires my work. Every single day, I take time to notice the light around me, to make notes about things that catch my eye, to file images, words, and thoughts, and to journal about moments and feelings. This constant gathering of ideas fuels me on a deep level. It motivates me to take lots of photographs and to live a more intentional life.

For this exercise, I invite you to create and photograph a "mood board" made up of inspiring visuals. I usually create a mood board by sitting on my studio floor with a pile of magazines. I start by ripping out pages and cutting out words and images that resonate with me. I don't give the process too much thought, preferring to let the theme emerge organically and intuitively. Once your mood board has been created, take a picture to document what is inspiring you now.

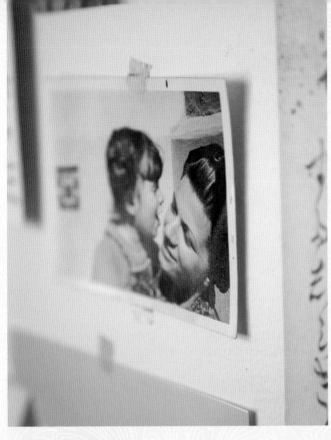

LEFT: Look for interesting ways to frame elements within your board. The photograph that is featured in this shot is framed by the edges of other images and stands out in between the two pieces of tape.

BELOW: Focus on a strong image or message in your inspiration board, and let the rest of the image fade to blur by choosing a large aperture setting.

INSTRUCTIONS

1. Gather inspiring visuals to create a mood board.

2. You can select images and objects randomly or based on a theme, such as a color scheme, portraits of people, travel, personal treasures, inspiring quotes, etc.

3. Use various sources of inspiration: magazines, family photos, fabric scraps, color chips, objects you treasure, souvenirs from your travels, etc.

4. Photograph your entire mood board or shoot a close-up of a particular section.

TECHNIQUES

- Pay attention to how themes, textures, and colors can complement one another. Your goal is to assemble and photograph a compelling image, so it is important to strive for a harmonious balance among the various elements.

- Use a **tripod** or prop your camera on a surface for stability.

- Glossy magazines and photos can be very reflective. Watch out for glare and undesired reflections.

SHOT IDEAS

- Create and photograph your mood board on a wall, table, or floor.

- Shoot your board very close and at an angle to capture revealing details.

- Shoot wide to show how the mood board is being displayed in a room, over your desk, etc.

"No one was ever great without some portion of divine inspiration."

—Marcus Tullius Cicero

Exercise 10: Your talisman

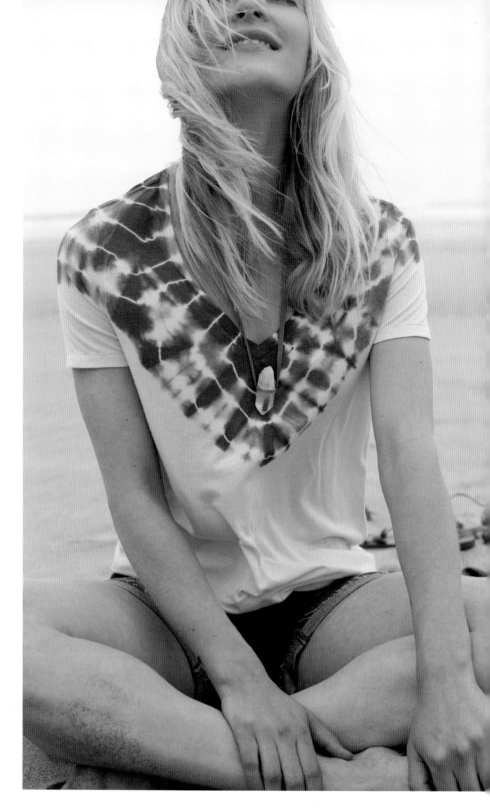

Talismans and lucky charms have been worn throughout history to offer protection and good luck. They tend to be small objects that range from ornaments such as jewelry to stones, bundled herbs, coins, crosses, and magical figures.

I believe that the power of a talisman is actually in the person who wears it rather than in the object itself. I have worn my talismans for years to express and remind myself of my deepest intentions. They are a tangible representation of my desires and help me stay focused on what I want to manifest in my life. In 2007, I was feeling frustrated with the lifestyle that I was leading and asked a friend to make me a necklace with the words, "Be the change." Within a year of receiving the talisman she made for me, I made important changes in my life that brought me more flexibility and greater alignment with my values.

Whether you believe in astrology, angels, unicorns, or in the power of crystals, I invite you to create a photograph that shows how you access your own magic! If you do not already have a talisman, photograph something that has special meaning and resonance for you, and the photograph will capture its power.

"Those who don't believe in magic will never find it." —Roald Dahl

INSTRUCTIONS

1. Wear, hang, or place your talisman on an interesting surface.

2. Ask a friend to model for you.

3. Highlight the characteristics or the elemental qualities of your talisman, such as an inspirational word, a type of metal, a precious stone, etc.

TECHNIQUES

- Backlight translucent objects to better highlight their features and to achieve more depth and detail in your shots.

- If your talisman is a shiny object, you can place a **black card** next to it to add contrast and detail, or you can use a **white card** to **bounce** light as needed.

- Minimize and avoid reflections by shooting at an angle.

SHOT IDEAS

- Hold the talisman in the palm of your hand.

- Take your talisman outdoors and shoot it in nature.

- Create an image that embodies the magic powers of your talisman, such as love, joy, affluence, etc.

FAR LEFT: This photo captures the girl's delight and empowerment but also prominently features the talisman in the center of frame. The pattern on her shirt forms a triangular shape that helps direct the eye toward the talisman, and her arms work as a diagonal line that leads to it as well.

TOP LEFT: In this shot, the soft light helps convey the reflective and translucent qualities of the talisman, and it also helps highlight a subtle pattern on the sand. The position of the hands and the leather straps both work as leading lines directing the viewer's eye through the frame.

BOTTOM LEFT: The light's position and intensity were carefully studied and chosen for this shot, as they help emphasize the talisman's multiple facets. The colored book works well as a base because it shows the object's transparency and thickness.

Exercise 11: Self-care and pampering

One of the best ways to gain self-knowledge is to observe how you take care of yourself. This includes the things that you do regularly to stay mentally and physically fit, as well as what you do to find temporary relief when you get off balance.

I find that visual reminders of what makes me feel good help me to stay focused on a positive lifestyle. In the year after my daughter was born, my time for self-care was scarce. Photographing small acts of self-love became a powerful way to stay afloat and to remind myself of what I needed in order to achieve balance in my day-to-day routine.

For this exercise, I invite you to look at how you soothe and care for yourself. If anything, this is a chance to use your photography to acknowledge or to bring more wellness into your life. Whether you shoot your own practices or the lifestyle of others for inspiration, your assignment is to create photographs that make you feel healthy, cared for, and alive.

ABOVE: The pale, soothing colors captured here help communicate the feeling of self-care. When shooting reflective surfaces, such as this silver token, shoot slightly from below and angle your item slightly upward to avoid introducing your own reflection into the shot.

LEFT: This mural of Krishna graces the wall of Yoga Tree Hayes Valley in San Francisco. Krishna consciousness inspires the reawakening of our natural, blissful state of being. Photograph things that remind you of how you can return to your original happy self.

BOTTOM LEFT: The beach is my most favorite place to walk and find my center. Photograph places you go to when you need to recharge.

INSTRUCTIONS

1. As you go through your day, take note of moments of self-care that you enjoy or be inspired by what you notice others do.

2. Look for visual reminders of what self-care means to you.

3. Use props to accent your shots and help you convey the message of self-care.

TECHNIQUES

- Bring your camera with you at all times and use it as a vehicle of self-care. The camera can help you slow down, breathe, notice, and capture the beauty around you.

SHOT IDEAS

- Document your glow after a run, a bike ride, or a yoga class.

- Photograph healthy meals, green juices, pedicures, and even the tiny indulgences that restore your energy when you are under stress.

- Shoot images that evoke relaxation, meditation, pleasure, ease, and joy.

"There are days I drop words of comfort on myself like falling leaves and remember that it is enough to be taken care of by myself." —Brian Andreas

Exercise 12: Whimsy

INSTRUCTIONS

1. When you set out to shoot a whimsical image, you need to play the part. Use wardrobe and props to create a character and get your message across.

2. Shoot at an interesting location or create a stage for your whimsical play.

3. Shoot wide to create a sense of place. The details of your environment can support your character and add meaning to the story you are about to tell with your shot.

TECHNIQUES

Depending on your camera:

• Use a **tripod**, self-timer, or remote to trigger the shot.

• Shoot with interesting film or process your digital images for an artistic look.

• Experiment with black-and-white images (film or digital) to add a "film noir" or documentary tone to your photographs.

SHOT IDEAS

• Use props such as hats, moustaches, and wigs.

• Look to fairy tales for inspiration—*Alice in Wonderland, Red Riding Hood,* and so on.

• Use glitter, Christmas lights, and sparklers for playful shots.

Embracing whimsy and playfulness in your photography can open up new artistic directions for you and your work. Silliness is a great way to connect with your inner child and to find unexpected ways of expressing who you are. It is also a very effective way to tell stories that pique curiosity, explore polemic themes, and pose questions of identity.

When I was a kid, I loved to play dress-up. I was fascinated by theater, fantastical worlds, and mystical creatures. As a photographer, when I think of whimsy, I immediately connect to the sense of wonder and fantasy that I craved as a child. That is the angle from which I choose to express my quirky side.

Who says that you are too old for make-believe? For this exercise, dare to shoot a whimsical self-portrait—if only for your own amusement! Use photography as your tool and your inner child as your voice. Do not let your inner critic stop you from having fun. And don't worry about creating a funny or edgy image. Perhaps your whimsy can be expressed in a more subtle or surreal way or maybe there is an odd, spooky side to it. Allow yourself to play and create your own magical world.

A simple element such as a mask can add whimsical interest to a shot. For this photograph, I looked for a background that resembled the habitat of a wild hare. Take a trip to a location that can infuse your shots with more personality and meaning.

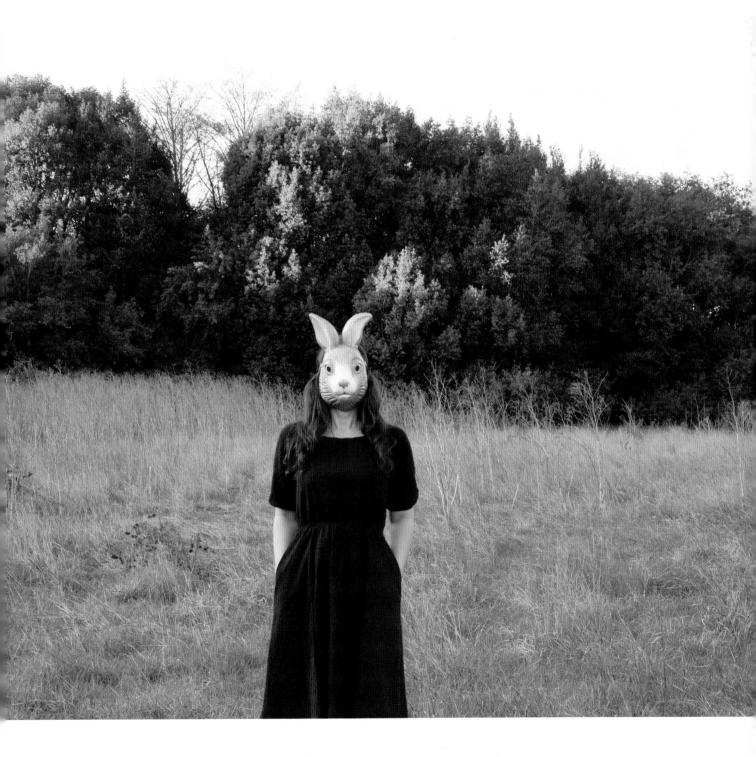

"Life is too important to be taken seriously." —Oscar Wilde

Chapter

3

Life:
Celebrating
the
Everyday

EPIC.

Exercise 13: Mornings

Before you begin documenting mornings with your camera, take a moment to write down some thoughts on what mornings mean to you. You can write about what actually happens in your household or you can fantasize about a different reality.

My mornings start with my daughter jumping in bed with me for snuggles. We linger for a bit, and I take a couple of minutes to notice the morning light. I love how it illuminates our curtains, wraps around our sheets, and carries with it the feeling of a fresh start. These early moments are beautiful, but they go by fast. We are soon off to school, work, and adventures. It is not until mid-morning that I finally sit with my calendar and drink my espresso. That is when my morning ends and my day begins.

Give it a try now. Writing down your thoughts and impressions will inspire you to shoot from a meaningful perspective.

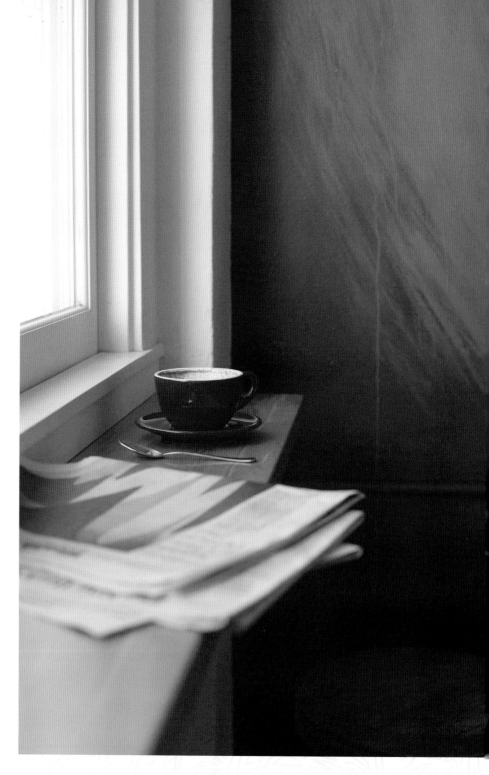

"For in the dew of little things the heart finds its morning and is refreshed."

—*Kahlil Gibran*

LEFT: Always take advantage of natural light coming from a window. When I took this shot, I was inspired by the soft window light and the quiet atmosphere. The deep blue background adds a nice contrast to the image. Use color to add interest to your images.

ABOVE: The unmade bed with the robe draped over it has a lingering energy, and it expresses the somewhat rushed nature of my mornings on most days. Look for moments of stillness punctuated by elements that tell a story.

RIGHT: Cats are all about contemplating a slow and enjoyable start to the day. They also know how to find a good spot to lie on. Follow your pet's cues to find beautiful **composition** and light.

INSTRUCTIONS

1. Study the qualities of the morning light. In the first few hours of the day, the color and intensity of the light changes quickly. You will notice that at dawn, the light is softer and cooler, and then pinks and reds get introduced. Later, when the sun rises, it becomes progressively stronger, warmer, and more golden.

2. Choose your photographic subject and capture a shot at each of the three stages of morning light.

3. Which light works best for your shot?

TECHNIQUES

- Use shadows to create a stylized look and create mood.

- Consider a **tripod** for shooting in low light.

- Shoot on cloudy days or with the light diffused by a white curtain to capture the "milky quality" of soft morning light.

SHOT IDEAS

- Photograph your bed.

- Take pictures of your breakfast.

- Record your morning rituals.

- Include your family and your pets in your photos. What are mornings like for them?

Exercise 14:
House chores

While housework may not be inspiring, it is a constant part of our lives. We can procrastinate and complain, but eventually, we all need to make the bed, wash the dishes, vacuum the carpets, sweep the floors, iron the clothes, and do the laundry.

The good news is that when we bring our cameras out to capture household tasks, we change our focus to what is interesting and escape the tedium of it all. As we compose our shots, we become enthralled in every little detail of the experience; and we learn to find greater meaning and beauty in the most ordinary moments.

As you work on your chores, notice how every messy corner has a hidden story that whispers moments well lived. Notice how your shirt drapes over the ironing board and how the sun lays its golden rays over the washed dishes. Document how you do your chores in a way that is unique to you or in a way that reveals something specific about this particular time in your life.

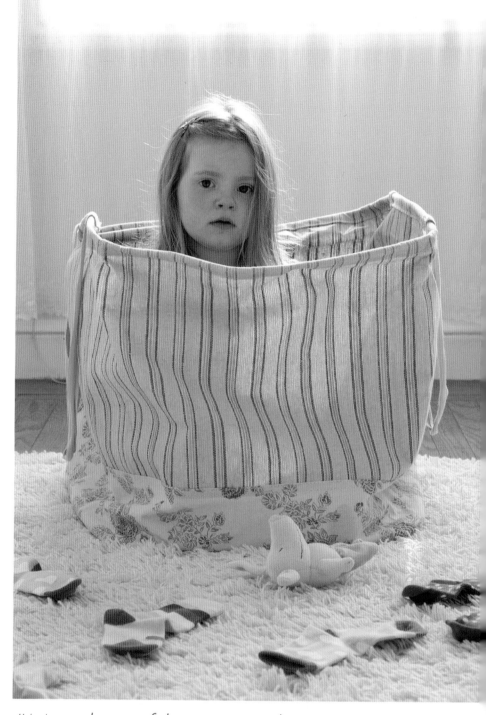

"My idea of housework is to sweep the room with a glance." —Erma Bombeck

INSTRUCTIONS

1. While in the midst of a chore, take a moment to notice your environment and bring your photographic eye to the scene.

2. Look at things from a different perspective. If you are sweeping, try moving your camera to where the broom meets the floor.

3. Shoot in an area of your home that has beautiful light. For instance, you could move your laundry basket closer to the window for a shot.

TECHNIQUES

Depending on your camera:

• Experiment with different film types (or use **digital processing**) to achieve different moods and to add drama to your photos.

• Experiment with black-and-white images (film or digital) to add a documentary quality to your photographs.

• Use a timer or a remote to incorporate yourself into your shots.

SHOT IDEAS

• Photograph your pet sleeping on top of freshly cleaned, warm laundry.

• Capture your just-washed sheets hanging on the clothesline.

• Take a picture of your child helping you to sweep the floors, or set the dinner table.

LEFT: Capture an unusual occurrence during a house chore. Keep an eye out for beautiful lighting, color, and spontaneity.

ABOVE: Zoom in on details such as clothespins and laundry items hanging on the line. By getting closer to your subjects, you are bound to find unexpected beauty in the mundane.

Exercise 15: Errands

Similar to chores, errands are necessary trips we take on a daily basis in order to keep things afloat in our lives. These include never-ending runs to the grocery store, the various pickups and drop-offs, and the many visits to the bank, post office, shoe repair, dry cleaning, hardware store, and more.

Sadly, because many of these moments aren't exactly memorable, we tend to rush through errands in order to cross them off our to-do lists. As a consequence,

everything becomes a huge blur, and the meaningful and relentless work we do to upkeep our homes and personal lives goes unseen.

That is where our cameras come into play. We can use them to slow down and to notice what we are doing, where we are going, and who is around us. After all, these seemingly ordinary events make up our lives, and by taking the time to document these moments, we create a true representation of how we spend our days.

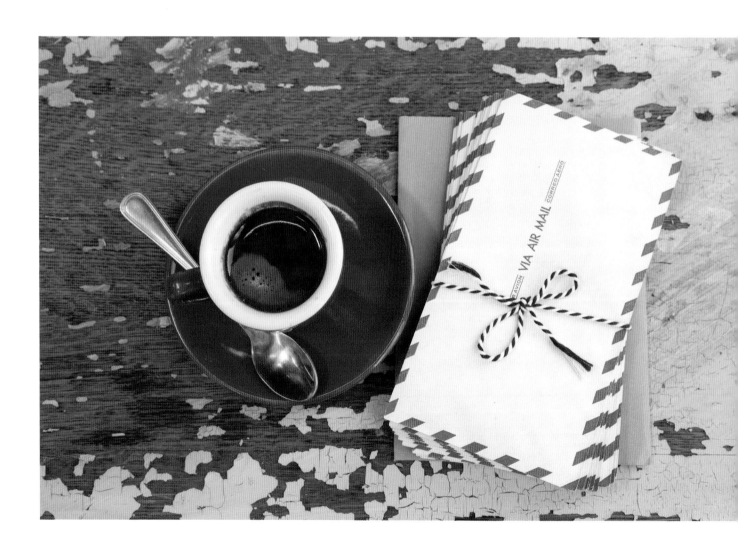

INSTRUCTIONS

1. While waiting in line and between pickups and drop-offs, notice the light, floors, windows, décor, and interesting characters around you.

2. Stage a shot with the elements of your errand by laying them on your car hood, sidewalk, or against a wall.

3. Document the weather, your means of transportation, and any encounters or sightings along the way.

TECHNIQUES

• When shooting in public spaces, working with a small camera helps you to remain discreet. Smartphones and compact cameras are great choices for this exercise. But do not limit yourself! Photograph with whatever tool you are most comfortable with.

Depending on your camera:

• A fast **prime lens** is a good choice when shooting in public. This type of lens is smaller and less intrusive than a **zoom**, and its large aperture capabilities are ideal for low-light and indoor shooting.

SHOT IDEAS

• Capture your favorite aisle at the grocery story.

• Take a photo of your child inside the shopping cart or your dog waiting for you outside a store.

• While waiting in line, document where you are standing and what you see. Photograph interesting floors and patterns.

FAR LEFT: Take a break and capture things you might be carrying with you on your errand. In this case, I had a pile of envelopes to mail and a birthday card to send to a friend. The pause for drinking an espresso was a great excuse to get creative. The textured table helped bring all the elements together.

MIDDLE: When I saw the beautiful shadows that were being cast onto the post-office wall, I immediately felt inspired to pull out my camera and take a photo. Keep your camera with you while running your errands. You never know when beauty might strike!

RIGHT: Remember to look up. The combination of branches, delicate leaves, blue sky, and shadows cast on the wall made for a captivating shot of an otherwise ordinary post-office façade.

"The magic of the street is the mingling of the errand and the epiphany."

—Rebecca Solnit

Exercise 16: Something you made

When we make something with our own hands, we not only feel great satisfaction but we also bring more beauty into the world. All the care and attention we put into what we make is a form of love, and that love makes everything look and taste better.

As photographers, we like to make images. We find the elements, we stage them, we frame and compose, we shoot, we develop, we print, and we share our work to inspire others. But for this exercise, I invite you to turn your camera towards the other lovely things that you make. It might be a handmade card, a knitted scarf, your own chai blend, a painting, or a meal. Pretty things and thoughtful details are ideal to photograph, and shooting the wonderful things that we make is also a great way to record the joy and sweetness that we generate for ourselves and for others in the most ordinary days.

What did you make recently that was rewarding and that made you proud, happy, and excited? If you didn't make anything recently, then make something and shoot it now. It can be something as easy as making a favorite dish, baking some cookies, or creating a collage.

"I want to learn more and more to see as beautiful what is necessary in things—then I shall be one of those who make things beautiful."

—Friedrich Nietzsche

INSTRUCTIONS

1. Style your shot with some of the tools, materials, and ingredients you used in your project. They will add interest and enhance the **composition** of your shot.

2. Put as much thought into the styling of your shot as you put into the making of your masterpiece. Take time to arrange all the elements to create a well-balanced image.

3. When applicable, use additional props and/or models to show the scale of your masterpiece or its function. For instance, use a model to photograph a scarf you knit or a piece of jewelry you created—or place a pillow you made on a chair to show how big it is.

4. You can also create a shot that captures the joy of sharing, wearing, and trying out what you made. For example, you could photograph a friend enjoying a piece of a pie you made.

TECHNIQUES

Depending on your camera:

- Either a fast **prime lens** or a **macro lens** is a good choice for throwing the background out of focus, which will emphasize the **focal point** of the image. The **macro lens** will allow you to get even closer to your subject and highlight details. You can also use the **macro lens setting** (compact cameras) for close-ups.

- Use a **tripod**, self-timer, or remote for a self-portrait of you working on your masterpiece.

SHOT IDEAS

- Photograph a tray of cookies right out of the oven with melting chocolate chips.

- Take a photo of something you knit or are in the process of knitting. Show your needles and wool spools.

- Capture your painting in progress or showcase the finished artwork.

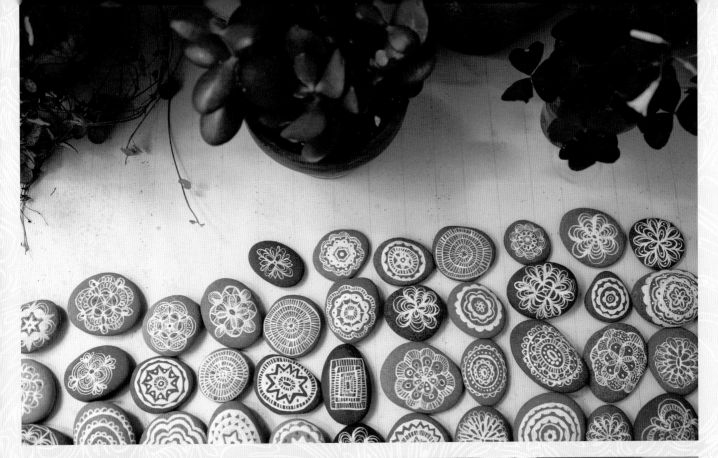

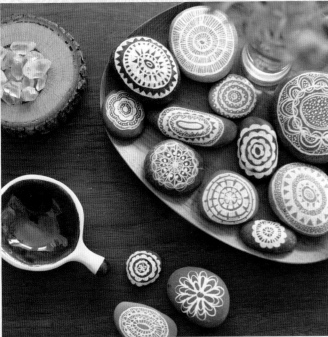

TOP: If you have made multiples, use an overhead shot to show variations in size, color, and design.

ABOVE: Add meaning and context to your handmade items by photographing them in a way that shows function and scale.

RIGHT: Show your process. You can set up a tripod and trigger the shot with a timer, or you can ask a friend to model for you.

Exercise 17: Capturing the seasons

The golden hour is the optimal time to shoot images during the fall. Notice how the warm tones get even richer and more saturated.

Each season has its own essence, offering new opportunities and challenges to photograph our world in a whole new way. As we tune into nature and look at the seasons through our lenses, we experience a sense of connection with our lives, as well as with everyone and everything around us.

The way we experience each season can also vary greatly depending on our culture and geographic location. I was born in Brazil, where it's difficult to notice the seasons change. Even so, there are subtle weather changes, festivals, and holidays associated with each season that inform us that time is passing and things are changing.

Since I moved to the United States, my perception of the seasons has dramatically changed because seasons are much more noticeable in this part of the world. These days, I feel much more aligned with nature's rhythms, and I am grateful for its cues that remind me to fully live each season of my life.

I love how everything comes alive in the spring, a time for new growth, flowers blooming, picnics, and Easter egg hunting. Summer is about sunshine and going on adventures. It's time for a vacation on the beach or at the lake, time to go camping and berry picking, and time to enjoy an ice-cream cone at the fair. By fall, I am ready to wear long

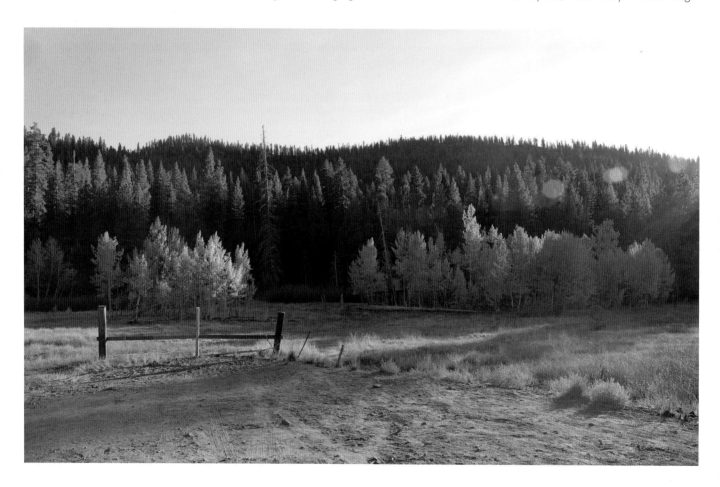

sleeves and eat pumpkin pie. Autumn is the season of falling leaves, and deep, warm colors. It is time to cuddle with a book, drink some spiced tea, and gather some energy before the cold winter comes. In the winter, if I am lucky, I get to spend some time in the mountains. For me, winter is about snow, bare branches, and the smell of pine trees. It is time for hot chocolate and special gatherings and a time for rest.

Think about what makes each time of year significant for you. Decide what you'd like to capture and try to connect those concepts to how you respond to the elements in your day-to-day life.

Photographing the same location throughout the seasons can be a rewarding and mindful experience. Use landmarks and structures to help you shoot from the exact same position all year long. If you want to be even more specific, take note of your focal length and exposure settings, so you can repeat the setup every season.

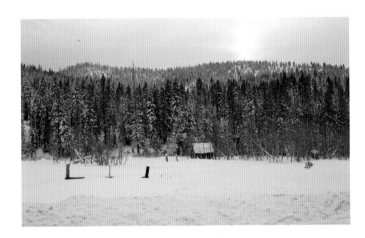

INSTRUCTIONS

1. Document what the landscape looks like at the current season. Then document the same landscape in every season to show how it changes throughout the year.
2. Focus on capturing the mood of the season: supple, energetic, grounding, restful, etc.
3. Picture seasonal foods, wardrobe, and activities.

TECHNIQUES

Winter: When shooting outside in winter, keep your camera and batteries inside your jacket, pocket, or camera bag. Batteries lose their power fast in low temperatures. When moving from the cold to the warmer temperatures inside, be careful that your camera and lenses don't get damaged due to condensation that can form if you shift too quickly. When shooting in the snow, look for colorful elements to provide contrast against the stark, white background.

Spring: When shooting flowers on sunny days, make sure you either shoot at early morning or late afternoon. Flowers are very sensitive to light and get easily overexposed. Alternatively, in hot sunlight, use a **diffuser**, such as a sheet of white fabric, or a **scrim** to avoid harsh lighting. You can also try to block the direct light with a card.

Summer: When documenting midday summer activities, shoot in "open shade" areas to avoid overexposure and harsh shadows.

Fall: In the fall, shoot late in the day at the golden hour (just before sunset). The afternoon's golden rays will emphasize the fall colors even more.

Depending on your camera:

- Get up early and experiment with a **macro lens** or **macro lens setting** to get beautiful close-up shots of morning dew, spider webs, flowers, insects, etc.
- Consider buying a waterproof case to protect your camera or smartphone, so you can get fun underwater shots in the summer.

SHOT IDEAS

- Document how various trees change throughout the year.
- Record seasonal family activities.
- Capture details that represent the essence and memory of a season—frost on a window pain, spring buds, or rainboots.

"Live in each season as it passes; breathe the air, drink the drink, taste the fruit, and resign yourself to the influence of the earth."

—Henry David Thoreau

Exercise 18: Weather

When it comes to photography and weather, most people mistakenly believe that sunny days are the best, if not the only, days for taking pictures. This is because we want to capture our lives at the brightest and most cheerful of times.

But deep down, we are drawn to all types of weather. Weather affects our lives in small and calamitous ways. Be it heat, rain, wind, or snow, we are fascinated by its unpredictable and mysterious nature. By capturing the essence and the effects of different weather conditions, we instantly add atmosphere and "interestingness" to our images.

For this exercise, look at the weather as your main subject matter. Perhaps it is too hot outside and all the windows are open, the fans are spinning, and people around you are sweating. Perhaps it is a rainy day and your child is out splashing in puddles, or it is snowing heavily and you are trapped inside the house. Maybe a storm is approaching and you are stuck in traffic. Or the wind is so strong that roofs are lifting off and trees are falling, in which case you should stay home or photograph from a safe indoor location! Create a photograph that shows how the weather is affecting your life or how you witnessed it affecting the life of others.

RIGHT: This shot uses the boat's circular frame as well as its diagonal rails to draw the viewer's interest into the scene. The open umbrella at the center of the frame adds impact to this shot and immediately communicates the message of rainy weather.

INSTRUCTIONS

1. Head outdoors or shoot from an indoor location.

2. Document the physical and emotional effects of a particular weather condition.

3. Picture weather-specific gear and activities.

4. If the weather is extreme, stay safe and shoot from inside a vehicle or building.

TECHNIQUES

• When photographing in wet weather, keep your camera dry at all times. Make sure that your gear is waterproof and not merely water resistant. If you are serious about shooting in wet conditions, consider a rain cover for your SLR camera and lens. Ask someone to hold an umbrella over you, attach an umbrella to a **tripod**, or hold an umbrella in one hand (secured in your armpit) and the camera in the other hand. Always carry spare plastic bags and rubber bands to protect your equipment in case you get caught in a sudden downpour.

• Watch out for your equipment in windy weather. **Tripods** can sometimes fall over in a big gust of wind.

• Do not change lenses during wind, rain, dust, or sand storms. Avoid getting specks of dirt, dust, sand, and water inside your camera and on your lens.

SHOT IDEAS

• Shoot rainbows, heavy fog, dark clouds, lightening, and reflections on wet ground. All of these elements can produce intriguing and magical images of weather.

• Catch someone splashing in a puddle.

• Capture the weather through a window or through a car's windshield.

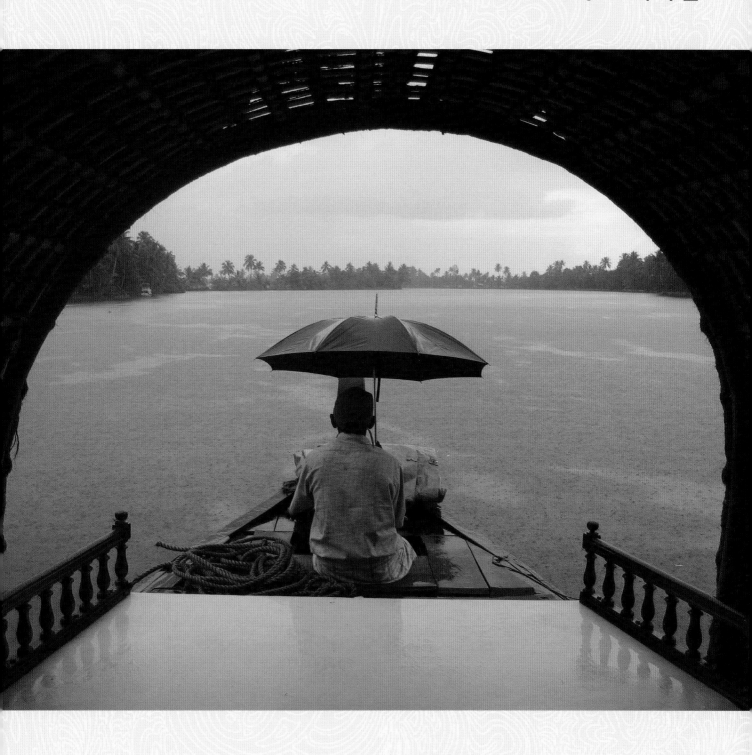

"Life isn't about waiting for the storm to pass . . .
It's about learning to dance in the rain." —Vivian Green

Exercise 19: Evenings

While mornings have an energy that is creative, productive, and refreshing, evenings invite slower rhythms and soothing activities. Traditionally a time for storytelling, evenings are also a time to decompress, to share a meal, and to process the day through conversation.

Since my daughter was born, we have embraced a daily evening routine. We often watch the sunset and welcome the deep blues of the night sky. Then we play for an hour before we sit down to eat dinner as a family. After dinner, it is time for bath, stories, lullabies, snuggles, and one last goodnight to the moon. This routine is simple, but it does wonders for my heart. It conveys to me how important it is to unwind and calm our senses before we fully let go of our day and give into rest.

For this exercise, notice what kind of imagery and energy you typically experience in your evenings. Images that appeal to me have a mysterious, romantic, and reflective nature, including sunsets, the moon, home, and warm lights against dark blue skies. Let this exercise be a chance for you to slow down and catch the last moments of beauty, stillness, and reflection in your day.

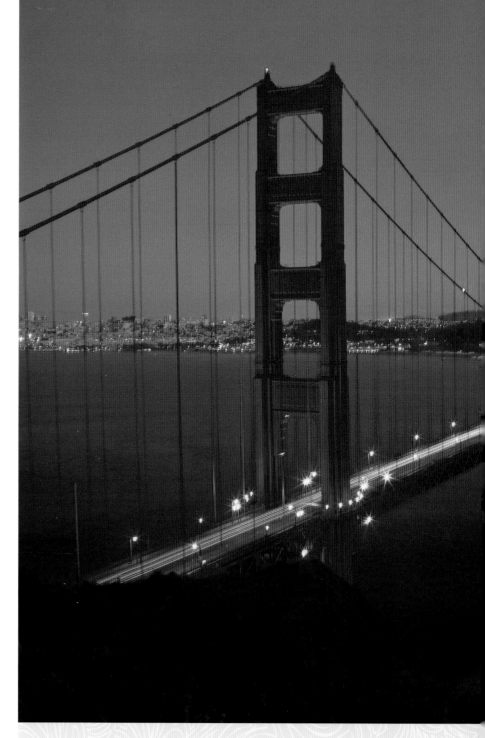

"My day is done, and I am like a boat drawn on the beach, listening to the dance-music of the tide in the evening." —Rabindranath Tagore

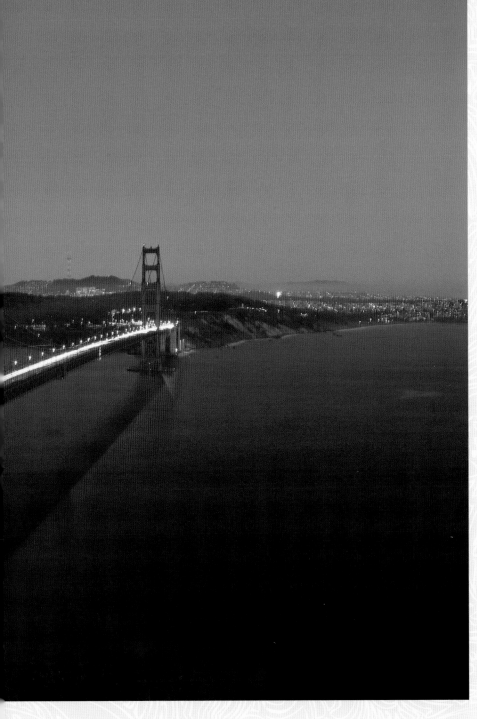

For this shot, I used the smallest aperture available (f/22), a really long exposure (20sec.), and a low ISO (200) to achieve a starburst effect and create light trails.

INSTRUCTIONS

1. Bring your camera to nighttime routines and winding-down activities.

2. Position yourself in a way that allows for you to take advantage of any natural light still available (30 minutes after sunset).

3. Use a headlight or flashlight to help your camera focus as needed.

TECHNIQUES

• In low light, even the slightest camera movement can result in a blurred image. Shoot with a **tripod** or by propping your camera onto a firm surface. If possible, for additional stability, use a remote to trigger the shot.

• Avoid using the flash when working with artificial light. Take advantage of light color and warmth to add atmosphere to your shots.

Depending on your camera:

• **Auto focus** may not work properly in low light. Use manual focus or turn on a setting called '**AF Assist**' if you are shooting with a DSLR.

• Capture moving lights or **light trails** by using a **tripod** to shoot with longer exposures.

• Create a **starburst effect** with a small aperture such as f/18 or smaller. You will need to compensate for the smaller aperture with a longer exposure.

• Shoot with a low ISO for best results, but if needed, bump the ISO to 800 or higher. Keep in mind that an image shot with a high ISO will have more **grain** or **noise**.

SHOT IDEAS

• Document your evening routines, such as dinner preparations and story time with kids.

• Capture the blue hour (30 minutes after sunset).

• Photograph lit bridges and city lights.

Exercise 20: Good mail

In this digital era, we can connect to each other instantly via email, texts, and various social media networks. But nothing can substitute a handwritten note or beautiful package delivered to our doorstep. When the norm is bills, junk, and propaganda, good mail can turn our day around and make us feel inspired and loved.

My mother-in-law is responsible for many "happy mail days" at our home. Several times a year, she surprises us with little trinkets from her travels, coloring books for our daughter, newspaper and magazine clippings, and gorgeous handmade cards that she paints herself using watercolors. I also love when my favorite magazines are delivered or when a friend surprises me with a card or a gift. These are moments worth capturing with my camera because I want to remember the thrill, the thought, and the feelings for years to come.

For this exercise, I invite you to photograph mail that makes your heart skip in excitement and gratitude. Be on the lookout for packages, magazines, and pleasant surprises that are appealing to photograph. You can also create and photograph your own lovely package to send to someone special.

In this shot, the packaging helps frame the magazine and adds impact to the main subject. The secondary elements and props help balance the image on the right side of the frame.

INSTRUCTIONS

1. Choose a background that will highlight the item that arrived in the mail. Consider putting it on a table, at your doorstep, on your bed, or inside the mailbox. If the item came wrapped, use the wrapping paper as a background.

2. Consider all the elements in your **composition** to make sure they complement one another.

3. Show scale by placing the package on an identifiable surface, such as a chair, or next to a recognizable prop, such as a cup of coffee.

TECHNIQUES

• Wrapping paper can be very reflective. Experiment with different angles to eliminate reflections.

• When photographing letters and cards, make sure you shoot in diffused lighting to avoid overexposing the whites of the paper and cardstock.

• Use a large aperture to throw the background out of focus and highlight details.

SHOT IDEAS

• Photograph the arrival of your favorite subscriptions.

• Take a photo of a special card or a thoughtful gift received in the mail.

• Shoot a flower arrangement that was sent to you. (Tip: Give the sender a copy of the photo as a thank-you!)

"Good things come to those who wait." —Unknown

Exercise 21: Work

One of the best things about photographing our work is that it gives us the opportunity to notice how we spend a large portion of our days.

Some of us choose to fill our work environment with things that contribute to an inspired work-life. Some of us prefer to avoid distractions, keeping clutter and embellishments to a minimum. Some of us are eccentric to the max while others are not aware of or in control of their workspaces. However you arrange your workspace, photographing how you and others work can be highly revealing and inspirational.

For years, I have been interested in images of how other people work. From artist's studios, to offices and factories, it is fascinating to journey through these realities for inspiration and to better understand and appreciate our own life.

RIGHT: This composition is very simple, and yet it uses lines, shapes, colors, and negative space to convey the mood of a peaceful workspace. Consider how the design of your shot communicates the atmosphere of your workplace.

OPPOSITE, TOP LEFT: This image features a meeting nook that is rich in color, texture, and detail. The glass of water and the brochure on the table help bring the eye to a resting place within the frame.

OPPOSITE, TOP RIGHT: The focus of this shot is the cappuccino, which conveys the idea of working at a café. Always think about what you want to communicate first, and then place your focus accordingly.

"How we spend our days is, of course, how we spend our lives." —Annie Dillard

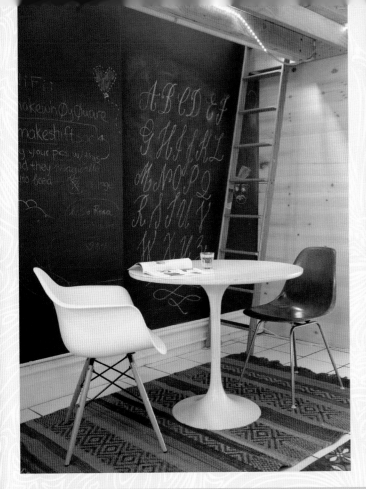

INSTRUCTIONS

1. When we spend our days doing the same old thing, we often look at things from a single perspective and see only what is right in front of us (usually our monitors!). Try shooting from an unexpected point of view.

2. Capture the architectural details: ceilings, staircases, interesting windows, arches, walls, etc.

3. Dig a little deeper and look beyond your desk. What do you wear to work? What are some of the tools and materials inside your drawers? What is the view from your workspace? What is hanging on the walls? What is down the corridor? Challenge yourself to see your work environment through a curious lens.

SHOT IDEAS

• Photograph your desk and your personal items.

• Shoot your space when everything is organized as well as when it is messy in the midst of a project.

• Document areas beyond your desk, such as a corridor, kitchen, meeting room, etc.

TECHNIQUES

• Notice the different sources of light available. Office spaces typically have a mixture of natural and artificial light.

• Shooting with various light sources can be a challenge in terms of color temperature. Whenever possible, make use of window light and turn off other light sources. By doing so, images will have more contrast, detail, and atmosphere.

• Watch out for unwanted reflections. Workspaces usually have lots of reflective objects and surfaces.

Depending on your camera:

• Shoot with a **wide lens** to capture architecture and to make rooms appear more spacious.

• Use a fast **prime lens** to capture details with a shallow **depth of field** and to photograph rooms with minimal light without a flash and **tripod**.

• A **tripod** is always a good choice when shooting indoors with low light. As an alternative, prop your camera on a steady surface and use a self-timer or remote to trigger the shot.

Exercise 22: Traditions

I had never given too much thought to the importance of traditions until I moved overseas. But when I was living far from home and on my own, the recurring events of the past suddenly made sense to me. They soothed my soul with a certain familiarity that made me feel grounded and safe. In moments of loneliness or sadness, traditions reassured me of my roots and my deep connections, and they reminded me that I could always find my way back to that unfailing place.

One of my most treasured traditions is spending New Year's Eve in Brazil. At midnight, on almost any beach, you can find thousands of people dressed in white, making wishes, jumping waves, and throwing flowers to Yemanja (the queen of the ocean). In recent years, I started a new tradition with my family. On the first day of the year, no matter where we are, we head to the ocean to make wishes and to jump waves.

What are some of the traditions that run in your family and bring you comfort, solace, and joy? How do you celebrate special occasions? Is there a regular family activity that you look forward to every weekend or every season? Do you attend a yearly gathering with relatives or friends? Do you have a skill or ritual that has been passed on to you by your ancestors or that you are passing on to your children?

The partial silhouette allows for just enough detail to be seen in the main subjects, and the overexposed background creates a luminous image. My daughter's pose, which was caught during a jump, adds energy and interest to the shot. Try to communicate the feelings associated with your traditions through an action shot.

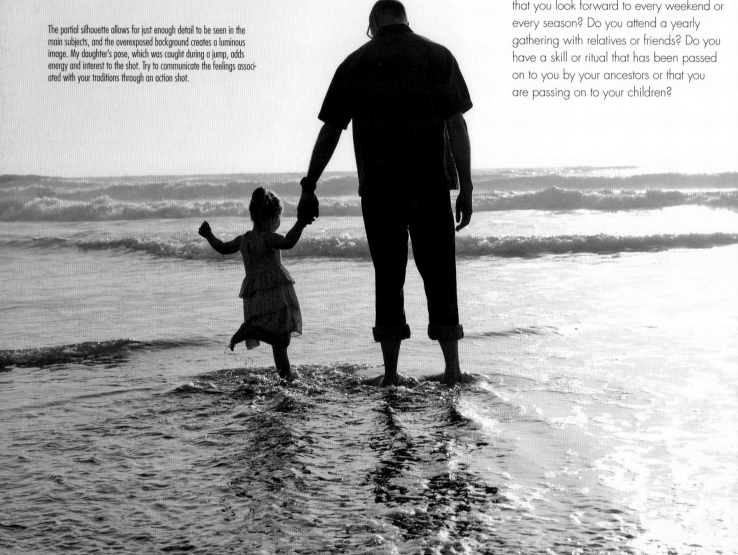

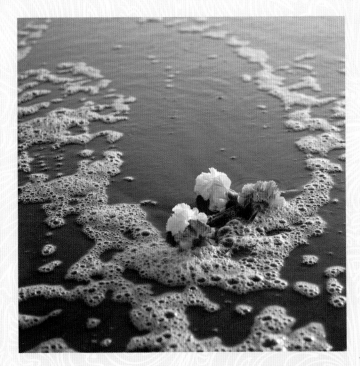

INSTRUCTIONS

1. Document a major celebration or significant reoccurring event or activity.

2. Photograph customs and skills passed down through generations in your family.

3. Get close to capture details that reveal meaningful aspects of your traditions.

4. Tell the story behind the tradition using a series of photos.

TECHNIQUES

Depending on your camera:

- Shoot with a **portrait lens** to capture the expressions on the faces of your loved ones. My favorites are Canon's EF85mm f/1.2L, EF24-70mm f/2.8L, and EF50mm f/1.4 or f/1.2. I also love the EF70-200mm f/2.8L, but it is a big **zoom lens** that is more suitable for professional shoots..

- Use a fast **prime lens** for shooting with a large aperture in low-light situations and also to achieve a soft, out-of-focus background.

SHOT IDEAS

- Photograph a seasonal outing, such as a winter ski trip, spring break vacation, berry picking in the summer, or a visit to the pumpkin patch in the fall.

- Document a family reunion.

- Picture some of your family rituals. These might include hanging your child's drawings on the fridge, Friday movie nights, pancake breakfasts, or celebratory dinners.

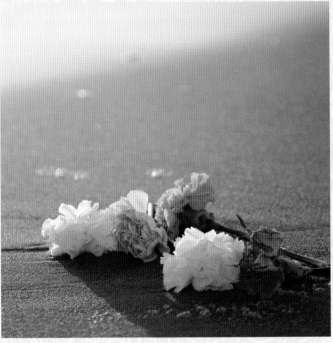

TOP: The sea foam acts as a framing element for the flowers and leads the viewer's eye from foreground to background. The dark background works well in contrast with the light-colored flowers.

BOTTOM: A very shallow depth of field helps the viewer maintain focus on the main subject. The unusual juxtaposition of flowers against a beach background generates curiosity about the story behind the shot.

"A year, ten years from now, I'll remember this; not why, only that we were here like this, together." —Adrienne Rich

Exercise 23: Play

What are the things that you do without any purpose other than to amuse yourself and have fun?

When I think back on my childhood, I clearly remember all my favorite ways to play. I used to line up my stuffed animals and dolls across the living room floor to teach them and to tell them stories. I loved drawing, painting, dancing, and dressing up. I rode my red tricycle, I splashed in the ocean like a fish, and I was crazy about stilt walking and trampolines. Later, I began writing and posting photos in my journals, collecting magazine clippings, flipping through photography books, and looking at world maps. I played alone a lot.

I believe that how we play in our early years informs how we learn and play for the rest of our lives. As an adult, I still prefer to play in solitude. I blog, I journal, I take photos, and I plan my classes and photo shoots—all quiet and introspective activities. I live in San Francisco, where dancing and dressing up is encouraged and where trampoline and stilt-walking opportunities abound. I am also married to a surfer, which means we are always chasing waves.

Play takes us back home to our true selves. Which playful activities did you use to love as a child? Were you into painting? Did you enjoy hopscotching or jumping rope? How do you play or wish you could play now? Too many people forget that playing is essential for emotional and intellectual development. As we grow older, we become fearful of doing things wrong and so we give up experimenting and we stop exploring. We associate playtime with unproductive, wasted time, when in reality playing makes us happier, healthier, and younger.

Photography is definitely a form of play, but for this exercise, I invite you to play first and then shoot or, in other words, play before you play some more!

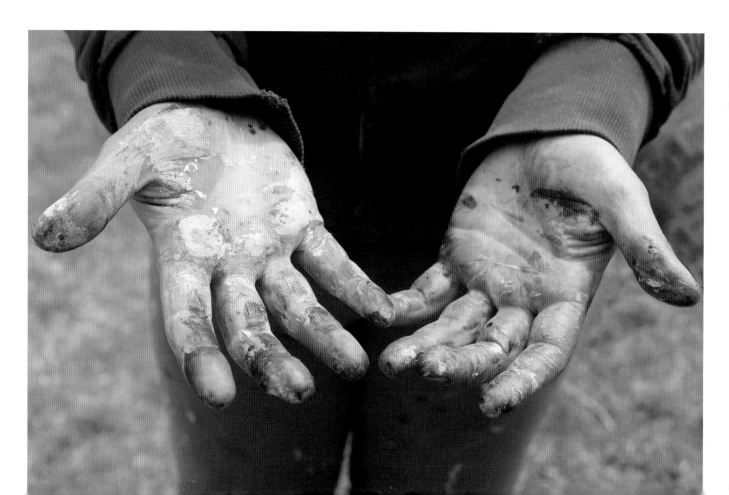

INSTRUCTIONS

1. Get playful!

2. If you don't know where to start, flip through your childhood albums and journals for reminders of what sort of things you enjoyed doing as kid. Re-create that image of you by playing the same way now.

3. Use colorful props, wardrobe, and backgrounds to enliven and add whimsy to your shots.

TECHNIQUES

• Play usually involves action. Experiment with different shutter speeds for capturing or freezing a moment.

Depending on your camera:

• A **portrait lens** is recommended. (See Exercise 22 for a list of my favorite choices.)

• Use a **tripod**, self-timer, or a remote to capture self-portraits of you at play.

SHOT IDEAS

• Photograph children at play and be inspired by their joy.

• Pretend you are five years old and capture that youthful spirit.

• Capture details that evoke memories of playful days, such as costumes, wigs, crayons, or a hula hoop.

Left: The shallow depth of field in this shot creates impact and helps emphasize all the colors and textures in the painted hands. Think of ways to photograph yourself or someone else after "playtime." Focus on elements that help you tell the story.

ABOVE: You can create playful shots with only a few simple elements. Notice how the use of color alone is enough to express a playful mood.

"You don't stop playing because you grow old. You grow old because you stop playing." —George Bernard Shaw

Exercise 24: Milestones and new beginnings

Milestones are those important moments in life that mark the passage of time. While these occasions can be very personal, some of them are universal, such as birth, a child's first steps and first words, the first day of school, the first kiss, graduation, first job, marriage, and a first child and grandchild.

Photography is one of the best ways to celebrate and record these pivotal and, at times, bittersweet events in our lives. From reaching small goals to developmental, academic, and professional achievements, it is through images captured during those times that we are able to preserve and share our memories with others.

Children are the best evidence of time passing. Like all mothers, I find myself trying to "stop time" when I press the shutter to document another "first" with my daughter. I want to remember everything, and I want my daughter to look back someday and know that every one of her tiny accomplishments was celebrated. Motherhood has also prompted me to shoot more of my own big moments so I can look back and share them with my daughter in the future.

What are the milestones, big and small, in your life?

For this exercise, choose a meaningful beginning or hard-earned accomplishment to document in your life or in the life of someone you love.

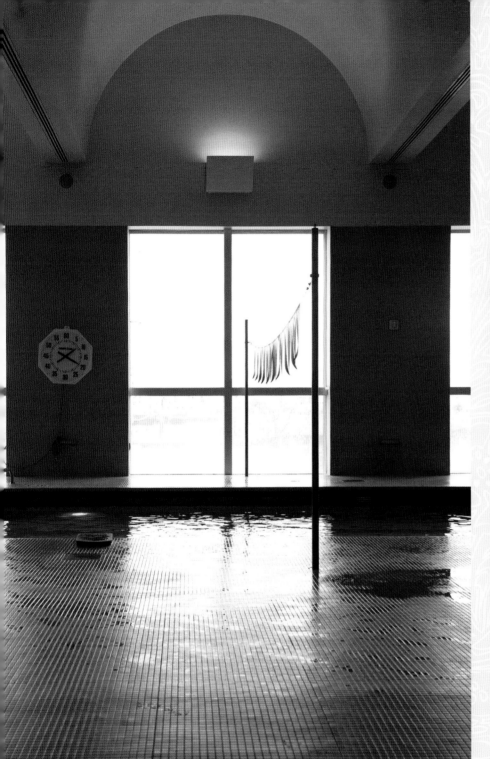

INSTRUCTIONS

1. While candid shots work best for almost every photo situation, when it comes to milestones, a posed shot can be quite powerful. Ask your subject to pose for you.

2. When photographing your children, set up the environment beforehand and then bring them into the shot, so that you can better achieve what you are envisioning.

3. Mementos can make or enhance great milestone photos. Photograph ticket stubs, flowers, menus, medals, diplomas, and so on.

TECHNIQUES

- Milestones are usually associated with a particular environment, such as school, a stage, or your home, for example. Shoot wide to create a sense of place.

- A **portrait lens** is recommended. (See Exercise 22 for a list of my favorite choices.)

SHOT IDEAS

- Capture your child's "firsts"—first steps, first day at school, first piano recital, etc.

- Photograph your own milestones, such as graduation, a promotion, and so on.

- Document your move to a new city or home.

FAR LEFT: In this shot of my daughter's first swimming class, I decided to capture her sitting on the edge of the pool as a metaphor for being on the edge of a new experience. Add hidden messages to your photographs. Even though the message may not be obvious, it will make a soulful impression on your audience.

LEFT: Capture the place where the milestone is happening or being celebrated. This photograph of the swimming pool uses lighting and symmetry to form a harmonious and contemplative image, a moment of stillness in between life's chapters.

"Then swing your window open, the one with the fresh air and good eastern light, and watch for wings, edges, new beginnings." —Monique Duval

Chapter **4**

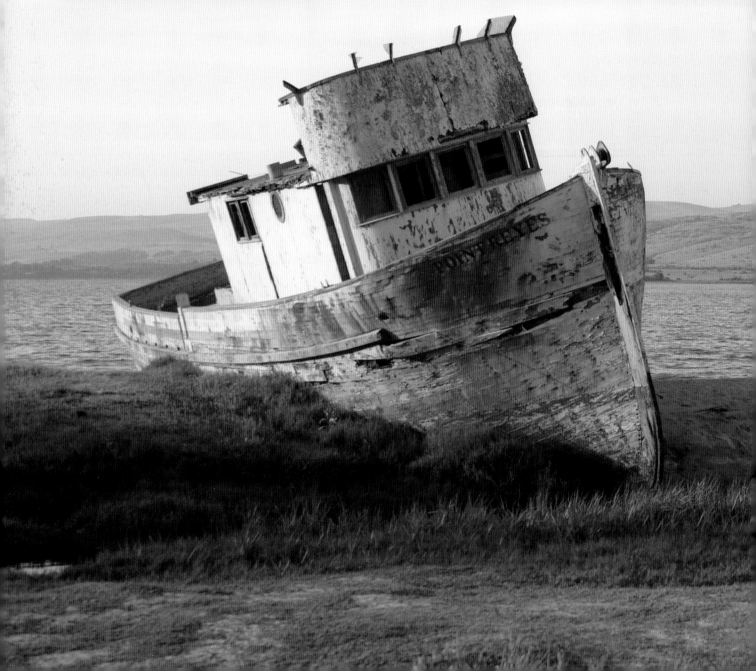

Wanderings: Taking the Scenic Route

Exercise 25: A walk in nature

Artists retreat into nature to find their voice and to create without distractions. Without the noise and stimulation of the city, they are able to better sort out their thoughts and make sense of their emotions.

I use my camera to sharpen my observation skills, to document my discoveries, and to re-create the deep sense of peace and grounding that I experience when I walk in nature.

For this exercise, go for a walk in nature and photograph from a meditative state of mind.

Notice the harmony in all the shapes, colors, and textures and how the sun shines through the trees. Let your intuition guide you. Notice your emotions as you go and think about how you might want to express those feelings in your photos.

ABOVE: Use a large aperture setting and a neutral background to draw attention to small subjects. The pale skin of my hand works well in contrast with the color and texture of the featured seeds.

ABOVE: Get down on your knees to shoot from a lower vantage point and to better capture the grand scale of the trees.

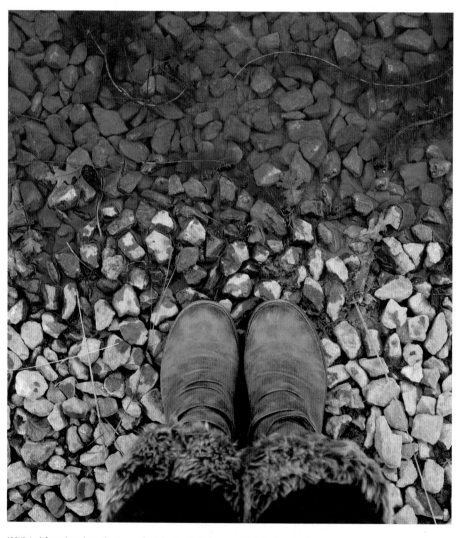

ABOVE: Look for earthy and grounding tones and textures. Here the textures present in the rocks, water, leather, and the fur on my boots complemented each other nicely and made for an interesting photo.

ABOVE: I easily could have missed the fly-fishing lures if I had not had my camera in hand and intended to pay careful attention to my surroundings. To capture interesting details, it is essential that you slow down and observe.

ABOVE: By positioning myself at a slight angle, I was able to capture the spider web with the sun behind it. The trick is to spend time moving around until it is possible to catch the highlights on the web. Take time to focus on the web itself, using a large aperture setting for a shallow depth of field. Blur out the background to avoid distractions.

> *"Nature's peace will flow into you as sunshine flows into trees."* —John Muir

INSTRUCTIONS

1. Shoot wide establishing shots of nature as well as close-ups of details.
2. Experiment with different angles to capture scale and textures.
3. When shooting upwards, **meter** the trees versus the sky to avoid a dark foreground.

TECHNIQUES

Depending on your camera:

- Consider a **tripod** if the woods are shady and somewhat dark.
- Consider a **macro lens** or a **macro lens setting** to capture details and insects and a **telephoto** to capture birds.

SHOT IDEAS

- Document different types of leaves.
- Photograph birds and insects.
- Take a wide panorama of a forest, lake, or meadow.

Exercise 26: A message from the universe

One of my favorite things to do is to find and photograph random messages from the universe. They might come as words, flowers, rocks, stickers, posters, or gestures from a stranger. These serendipitous findings are sometimes chalk marks on a sidewalk, notes stuck on sign posts, painted rocks tucked into the grass at the park, tagged walls, or words written on the sand at the beach. The possibilities for finding these messages are endless, and it fills my heart with excitement to know that hope and love are waiting for us in the most unexpected places.

For this assignment, I suggest you wander off your beaten path. Take a bus to a neighborhood that you don't normally visit, change your route to work, or walk instead of driving to your destination. Leave your skepticism at home and infuse your walk with openness and a spirit of adventure. Welcome the surprises that the universe has in store for you and have fun shooting!

Even though I could have zoomed into the message in this shot, I decided to go wider because the environment surrounding the message seemed to make it even more inspiring. Decide whether it is helpful or distracting to include more of the background in your shot.

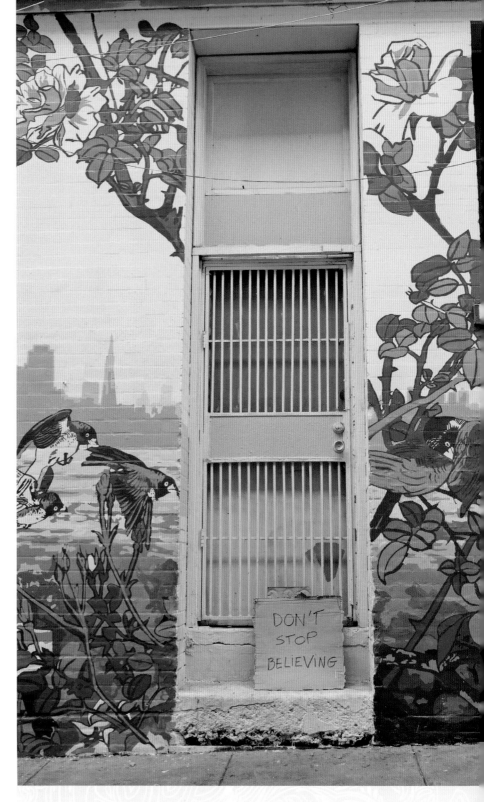

"If you are waiting for a sign, this is it." —Anonymous

INSTRUCTIONS

1. Photographing messages from the universe is a simple and soulful process. First and foremost, you need to slow down enough to notice what the universe has to offer you.

2. Once something catches your eye and touches your heart, pay attention to how the light looks in that environment. Make sure that the message is clear and not obscured by shadows or glare.

3. Eliminate any clutter from the frame that might interfere with the main interest of your shot and focal point—then shoot away.

TECHNIQUES

Depending on your camera:

- Particularly when shooting words, choose a small aperture to make sure your entire message is in focus.

- Alternatively, you should use a large aperture if you'd like to separate your subject from the background. Just make sure your focus is on the message.

SHOT IDEAS

- Photograph messages tagged on walls, trucks, etc.

- Take a photo of a note, poster, or object that gets your attention in the street.

- Shoot inspirational words written on the sand or ground.

TOP: The charcoal background here helps frame the message, and it works well with the greenish and grayish tones of the collage at the bottom of the frame.

BOTTOM: In this shot, the tea bag string helps direct the eye toward the message. Evaluate if there are any elements in your shot that can be used as leading lines to direct the eye towards the image's focal point.

TIP

Turn your "message from the universe" photos into desktop wallpapers, fridge magnets, stickers, and postcards. You can keep them as your own soulful reminders or give them to family and friends. Everyone likes a love note!

Exercise 27: Window shopping

Nothing beats a good shopping trip where your wallet stays intact. Stores put a great deal of effort into styling their windows to attract shoppers by using props, decorations, lights, and even live entertainment. Their eye-catching set designs can also be wonderfully inspiring for photographers. Windows offer opportunities to capture styled scenes, mannequins, and reflections of self-portraits.

There is no shortage of well-designed windows in big cities, but even small towns have interesting storefronts that are worth capturing. From glamorous department stores to quirky, retro storefront windows, from clothing to jewelry, from restaurants to cafés, there is plenty of beauty waiting to be captured behind the glass.

On your next photo walk, look for windows that display interesting stories about their products, their audiences, their location, or the season. Notice how the elements inside the windows, as well as those reflected on them, can be incorporated into your photos to create compelling images.

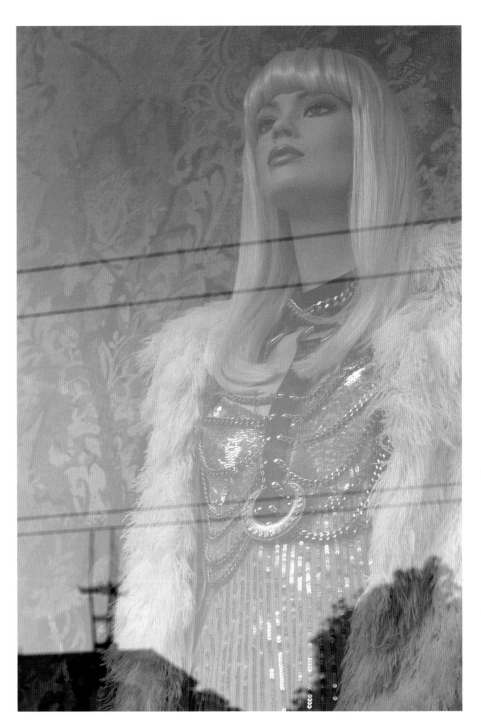

ABOVE: I opted to work with the reflections on the window to give my shot a "double exposure" look. The reflection of Twin Peaks (a landmark in San Francisco) added a sense of place to my shot. Decide whether reflections can enhance or obstruct your shot.

RIGHT: Here, too, I worked with the reflections on the window. I used them to help frame the mannequin and to add context to the shot. Compose your shots of window mannequins as if you were working with a model. Look for interesting angles to feature poses and outfits.

INSTRUCTIONS

1. When shooting a window display or storefront, you can choose to include or avoid reflections.

2. To avoid reflections, shoot within shadowed areas (even using your own shadow projected onto the glass), shoot at an angle of 45 degrees to the window, shoot through a hole on black cardboard or fabric, or place your camera right against the glass. You can also shoot at night if the window's interior is well illuminated.

3. When including reflections, make sure they do not compete with the **focal point**. Use reflections for an artistic look and to highlight or **frame** your subjects.

TECHNIQUES

Depending on your camera:

• Use a **polarizing filter** to remove or reduce reflections. Place this magic filter on your lens and slowly rotate the filter until the reflections and glare are gone. The results are astounding!

• Make sure that your **flash** is off to avoid additional glare.

SHOT IDEAS

• Photograph seasonal window decorations.

• Picture a live window display.

• Shoot the front window of a restaurant, bakery, or café.

"To photograph a thing is to appropriate the thing photographed." —Susan Sontag

Exercise 28: In the city

Forests and meadows may have their charm, but cities offer an amazing combination of architecture, diversity, and contrast that can be very stimulating for photographers. From skyscrapers, churches, and iconic sites, to street performers, graffiti, and people rushing by, the opportunities to shoot are endless.

Taking heartfelt photographs in a rich and vibrant environment can also present challenges. The commotion and the constant noise can be at odds with our intention to slow down and to find beauty. Choosing a theme to focus on or a particular area to shoot will help you filter out the sensorial overload.

For this exercise, go on a photo walk in the city. Whether you are a resident or a visitor, approach your surroundings with curiosity. Think of someone with whom you would want to share your experience. Shooting with a particular audience in mind often translates into images with a stronger and more focused message.

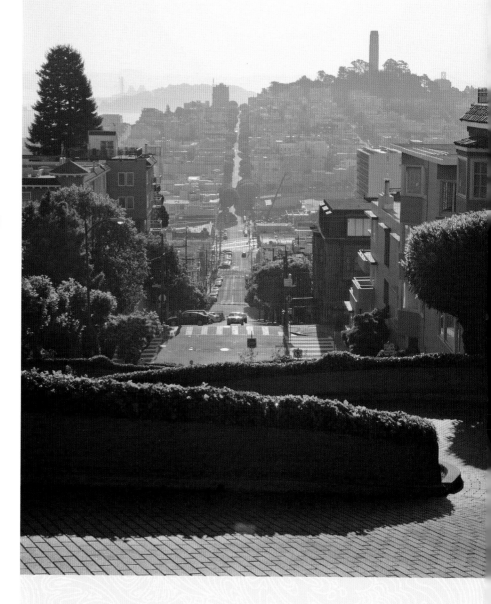

Photograph major city attractions and landmarks early in the morning to avoid traffic and crowds. Notice how the early morning haze helps create a sense of depth in this shot, and how the empty streets contribute to a clean and uncluttered view of the city.

"The life of our city is rich in poetic and marvelous subjects. We are enveloped and steeped as though in an atmosphere of the marvelous; but we do not notice it." —Charles Baudelaire

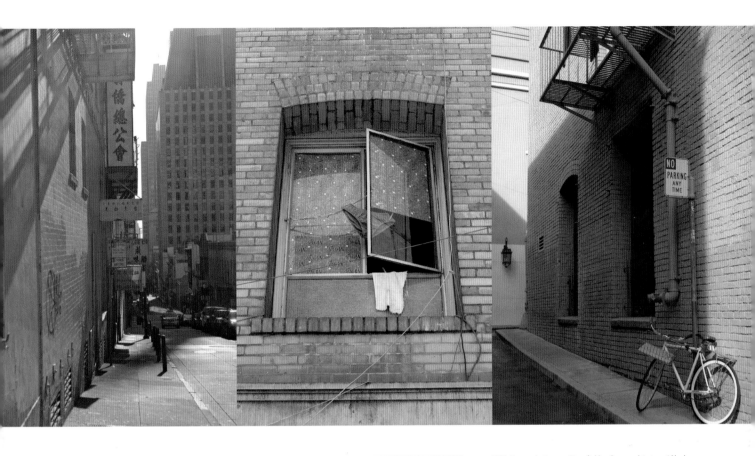

INSTRUCTIONS

1. Photograph a city waking up to business.

2. Document an increasing level of activity as the day goes on.

3. Once things get busy, find a spot to sit and observe before you shoot.

4. Look for and capture details that often go unnoticed by those who just rush by.

SHOT IDEAS

• Capture the contrast between traditional and modern architecture.

• Photograph city dwellers.

• Find a secret or unexpected city perspective away from the hustle and bustle.

TECHNIQUES

• Use **leading lines**, **shapes**, **framing**, **symmetry**, **patterns**, and **juxtaposition**.

• Play with perspective and scale by shooting toward the sky and by shooting down from the top of a building or a tall parking garage.

Depending on your camera:

• Shoot with a variety of lenses to capture both wide scenes and small details.

• Play with shutter speed settings to capture the movement of vehicles and people and to track lights. A slow shutter speed setting will create blur or streaks where there is movement.

LEFT: Capture the juxtaposition of old and new architecture. I like how the soft light shows the texture of the wall and how the long shadows act as leading lines that help the composition come together.

MIDDLE: Slow down enough to notice details that often go unnoticed. Look up! The colorful curtains and hanging laundry tell a story and pique the viewer's curiosity.

RIGHT: A shot of a bike leaning against a brick wall is somewhat timeless. Think of how you can capture a scene that can be appreciated all over the world for years to come.

Exercise 29: Head in the clouds

Lower your horizontal line as needed to include more of the sky in your shot. It's okay to break some rules once you have learned how to use them.

Having a record of what the sky looked like on the special days in our lives adds meaningful context to our memories. Wouldn't it be nice to know what the sky looked like when you had your first kiss, when your baby was born, or when you quit your day job to pursue a dream? Including the sky in our pictures is a surprising way to add depth to our lives and to our photos.

The sky can also tell wonderful stories about the weather and our moods. The sky before, during, and after a storm can be extraordinary with dark clouds, lightening, and rainbows. On a clear day, the sky can be the most perfect cobalt blue. Other times, it can seem downright cheerful, dotted with fluffy white clouds.

When I am feeling low, I find comfort by noticing that we are all held under the same giant blue dome. Despite our differences and the challenges we face, we are all on this planet together, looking for hope, and wanting to feel loved.

Can you relate how you feel to the sky above you? For this exercise, all you have to do is look up and take notice. What does the sky look like? What story does it tell—about you, the weather pattern, or the world at large?

ABOVE: Sometimes the sky can be hard to miss, such as in this apocalyptic shot. But on other days, it may require more effort on your part to look up and enjoy beauty that is above eye level. If the sky is absolutely striking, you may want to expose for the sky and let the foreground element be dark and silhouetted.

BELOW: Rainbows should never be missed! In this shot, the bottom of the frame is on the darker side, so the eye immediately travels up and rests on the sky and rainbow.

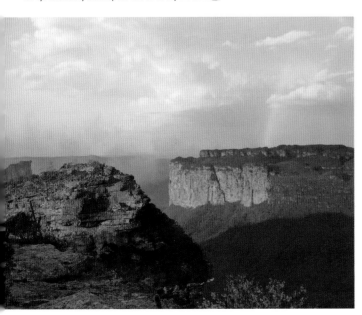

INSTRUCTIONS

1. As a general rule, when a shot is focused on the sky, you should **meter** for the sky to avoid losing its detail and color. However, you may cause your foreground to get too dark. To compensate for this and brighten up the subject in the foreground, you can use a **fill flash** or balance the image in **manual mode**, adjusting the aperture and shutter speed to achieve balance.

2. You can also use the contrast between the bright sky and dark foreground to capture interesting **silhouettes**.

TECHNIQUES

• Learn and then break the **rule of thirds**. When shooting the sky, you can break this rule by placing your horizon line very low, allowing the sky to fill most of the frame. You can also fill the entire frame with sky.

Depending on your camera:

• With a compact camera in bright daylight, the **in-camera flash** may not come on automatically, so you will need to turn it on manually.

• When shooting digital, you may continue to adjust **levels** and add more **fill light** in the editing phase. Shoot in **RAW mode** to have more flexibility when making this adjustment. Finally, if you're shooting with a camera that does not offer much exposure control, do not shoot toward the sun. Shooting with the sun behind you or coming from the side will allow you to get more detail out of your sky.

SHOT IDEAS

• Photograph the sunrise or sunset.

• Capture interesting cloud formations.

• Document what the sky looks like on a special day in your life.

"Clouds come floating into my life, no longer to carry rain or usher storm, but to add color to my sunset sky."

—Rabindranath Tagore

Exercise 30: Cafés

Artists and intellectuals have been gathering in cafés for centuries to share ideas, write, read, and spend time alone.

For those of us who wander with our cameras, the creative atmosphere of cafés offers numerous subjects to photograph, including interesting people, funky décor, latte art, and local culture.

I am particularly inspired by the general mood that exists in cafés. Whether it is a hip spot with sleek espresso cups or a hidden neighborhood gem with mismatched mugs, there is always abundant character to be captured in each place. One of my favorite things to photograph is a still life infused with the energy that a customer leaves behind. Plates with crumbs, half-empty glasses, and discarded newspapers scattered over tables are some of my favorite subjects. I am also moved by the art on café walls, how the light warms empty chairs, the rhythmic buzzing of collective voices, and the constant brewing of strong coffee and new ideas.

For this exercise, pick a café to linger in. Watch the people, study the light, and take some photos. You may also extend this prompt to capturing the spirit in other small eating places.

"If you stay in it for any length of time, like anyplace else, a café becomes a world."

—Marisa de los Santos

ABOVE: I could have had a brighter photo here if I had shot from the opposite end of the café facing in, but it would have been a flatter image as well. Instead I decided to feature the beautiful windows, and I embraced the darker side. Resist the urge to see everything bright in the frame. Darker areas can help create mood and contrast.

ABOVE: Tell the story about what makes the café you frequent a special place. If, for example, it's known for having amazing pastries, by all means try to capture them in your shots.

ABOVE: Featuring details such as espresso machines, cups, and counters is an effective way to capture the style of your favorite café. If there are too many distracting elements in the background, use a shallow depth of field to help the viewer focus on what is most important.

INSTRUCTIONS

1. Shoot in locations that are properly illuminated by natural light and explore the contrast between light and dark areas.

2. If outdoor seating is available, take pictures indoors and outdoors to compare the different moods that can be achieved depending on the different lighting.

3. Ask for permission from the owner or manager before you begin shooting, and if requested, explain how you intend to use the photos, such as personal use, editorial submission, etc.

4. If you intend to shoot candid portraits, ask for permission from your subjects, or ask a friend to model for you.

TECHNIQUES

• A **tripod** is always useful in low-light situations, but you should definitely ask for permission from the cafe owner first. Alternatively, you could prop your camera on a table or counter and use the self-timer or remote to trigger the shot.

• Sidelighting is really effective for capturing the warmth and atmosphere of interiors.

• Experiment with a slow shutter speed to blur people's movements, such as customers walking in and out, servers carrying food and beverages, etc.

• Turn off your **on-camera flash** which is sure to kill the mood of your photo, disturb patrons, and call too much attention to what you are doing.

SHOT IDEAS

• Shoot from outside of the cafe through a glass door or window.

• Photograph a perfect latte or a particular drink or dish that the café is famous for.

• Capture interesting details, such as unusual fixtures, plates, and elements of décor and style.

Exercise 31: Markets and stalls

Markets are some of the most vibrant and colorful places to photograph. They offer countless subjects and themes to explore.

There are open-air markets, indoor markets, and night food markets. There are flea markets with vintage objects, furniture, and apparel for sale. There are farmer's markets that offer locally sourced goods, meats, and produce. And there are markets that exclusively sell fish, flowers, clothing, or spices. Regardless of what type of market is nearby, there is plenty of fun to be had with your camera. When I began shooting more regularly, visiting big markets was overwhelming. So once a month, I would drive up the coast to a small town to shoot gorgeous, fresh produce at a tiny roadside stall. For this exercise, check out big markets and single-market stalls to see which appeal to you and pique your artistic sensibilities. They are all great places for studying light, **composition**, **depth of field**, perspective, color, and portraiture. And shooting at markets is a fun way to get to know and capture the local community.

In this photo, color and texture are the focus of the shot. But what helps the composition come alive is also the fact that the elements on the table aren't perfectly ordered.

INSTRUCTIONS

1. Photograph the vibrancy of a sprawling market or the unique character of a single market stall.

2. Ask vendors and customers for permission if you want to take their portrait or when you need to get closer to products.

3. Shoot close-ups of products to fill the frame with color and texture and then shoot wide to capture the setting of the market.

4. Do not rush and zoom in from far away. Give yourself time to find the right angle and **composition**.

5. Use color, **shape**, texture, and **pattern** to create interest.

TECHNIQUES

- Use a fast **prime lens** with narrow **depth of field** to capture details and separate foreground elements from the background.

- Shoot with a **wide lens** to emphasize the setting and to include more of the surrounding area.

SHOT IDEAS

- If there are buildings nearby, shoot the market from above for a different perspective.

- Photograph market displays, baskets, and signs.

- Take portraits of vendors.

"A wicker basket gapes and overflows. Spilling out cool, blue plums. The market glows ..."

—Amy Lowell, "Market Day"

Exercise 32: Beachcombing

Photographing birds on the move can be challenging. Try a fast shutter speed to freeze their action or experiment with panning.

Kids are naturally drawn to collecting rocks, driftwood, and seashells that wash up on shore. But as we grow older, these little treasures tend to go unnoticed.

Beachcombing with our cameras is a great way to reconnect with our original spirit of curiosity and exploration. When we go on mini photo expeditions along the shore, we take a closer look at nature, and once again, we are able to find the magic right where we stand.

My daughter is an avid explorer and a keen observer. When we walk on the beach together, she usually spots interesting shapes before I do. She holds these tiny treasures in her hands and examines them like a true historian. Her sense of wonder teaches me that when we pause and study the world, we are able to see ordinary things in an extraordinary light.

For this prompt, put on your flip-flops, strap your camera around your neck, and walk the beach with any eye toward discovering what's hidden right in front of you. Explore the shoreline of an ocean, lake, or river near where you live.

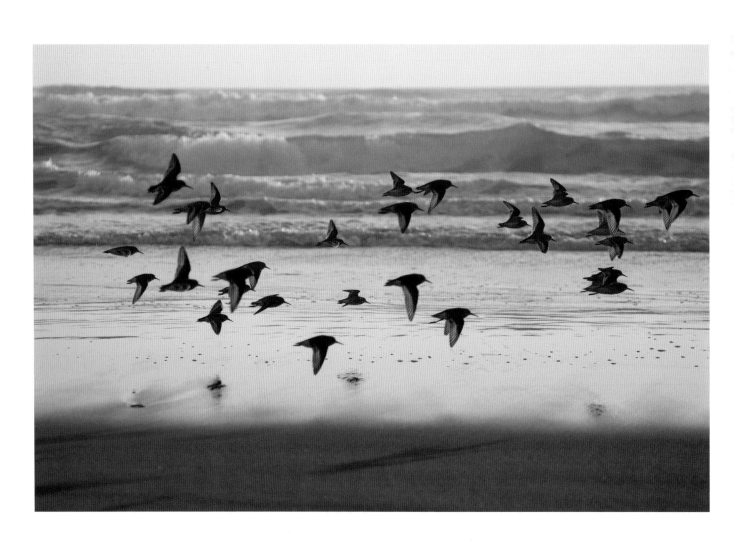

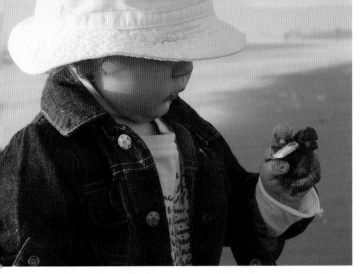

INSTRUCTIONS

1. Capture the unique aspects and elements of a shoreline.
2. Look for other backdrops besides the ocean, including dunes, piers, rocks, and palm trees.
3. Be mindful of the light. The best times to shoot at the beach are early morning and late afternoon.
4. Experiment with different perspectives, such as ground level or from above.

TECHNIQUES

- When taking portraits, make sure you don't shoot when the sun is high, which will cast undesired shadows on your subject's face. Instead you should favor soft sidelight or backlight.
- Use a **macro lens** or **macro lens setting** to capture details, such as shells, crabs, or driftwood.
- Shoot with a **wide lens**, **fish-eye lens**, Lensbaby for **lens distortion** effects.
- Consider a **zoom lens** for greater flexibility and to maintain a comfortable distance from your subjects.

Depending on your camera:

When backlighting, try using your **AE lock** to lock the exposure setting. Several digital cameras have this button. Here's how: First, **meter** your subject while pressing the **shutter button** halfway down. While pressing the shutter halfway down, press the **AE lock** button to lock the exposure and focus. A star symbol will light up on your **viewfinder** when the exposure has been locked. Once that is set, you can let go of the **shutter button** and reframe the image as needed before you take the shot. This will result in a slightly overexposed background or sky, but your subject will be perfectly exposed. The effect can be magical! When working with this technique for portraits, use spot **metering** for best results. This technique also helps to ensure exposure continuity when shooting a series or a panorama.

SHOT IDEAS

1. Photograph the beach and how others enjoy and interact with it.
2. Document your own footprints and where they take you.
3. Take pictures of what you discover at the water's edge, such as shells, sea glass, debris that's washed ashore, and reflections.

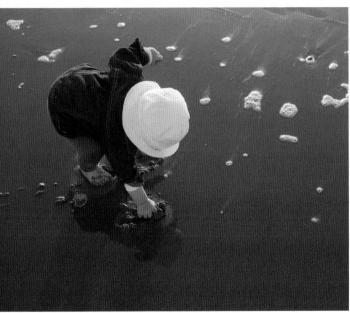

Top: Candid shots such as this one offer the viewer a window into a genuine and spontaneous experience. Too often we tend to interrupt quiet moments with questions or observations. Take time to watch and capture an unscripted moment of wonder.

Bottom: The rule of thirds was used here to create balance in the composition. Notice how the placement works with my daughter's pose — leaning forward. The sea foam helps guide the eye as it travels across the frame diagonally, and it adds detail and interest to the background.

"Our memories of the ocean will linger on, long after our footprints in the sand are gone."

— *Unknown*

Exercise 33: Countryside

The countryside is a rich landscape to explore with our cameras. Without noise, buildings, and other distractions, we are able to see as wide as the open sky and as small as a blade of grass.

Even though I was lucky to grow up close to a beach, some of my best memories from childhood are the times I spent in the countryside. It was there that I felt the most awake and interested in life. In the country, everything made sense: waking up early, doing chores, caring for the animals, and eating the food that we had harvested that day. Life was simple and connected.

For this exercise, capture a slice of rural life at its best! Drawing from your personal experiences in the country, photograph what makes the landscape and setting both memorable and evocative for you.

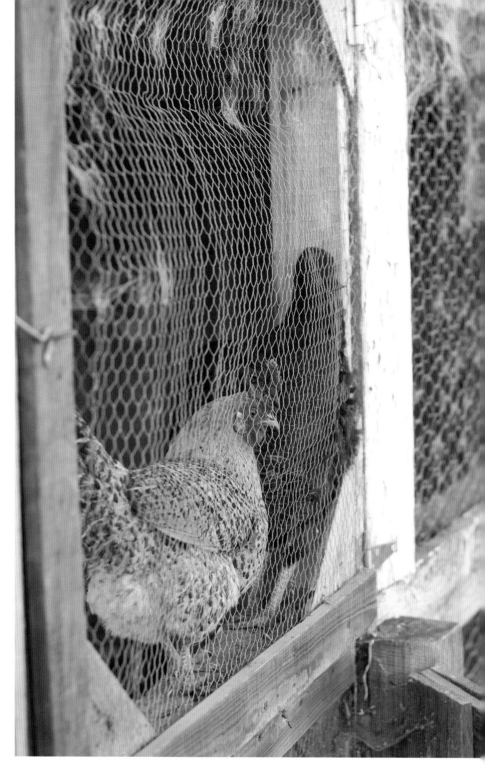

"When I go out into the countryside and see the sun and the green and everything flowering, I say to myself, 'Yes indeed, all that belongs to me!'" —Henri Rousseau

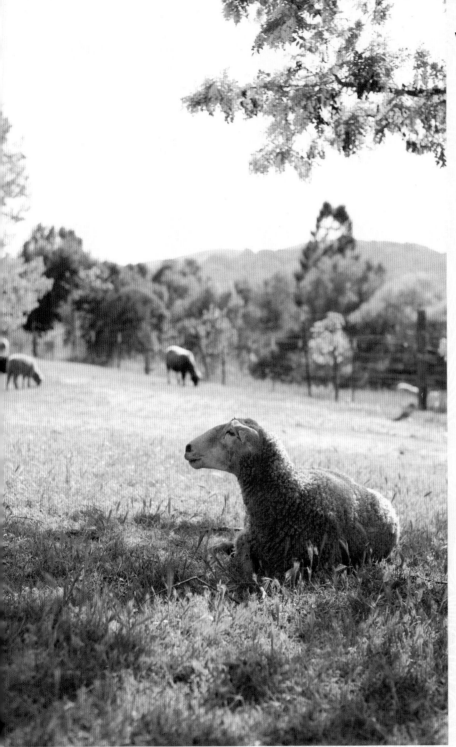

LEFT: In this shot, I aimed for a sharp focus on the chicken as opposed to the wire. When shooting animals behind fences, in between gates, etc., take time to make sure your focus is on the animal itself. Sometimes the camera's autofocus will naturally pick up the element that is closest to it.

ABOVE: The light may be too bright when shooting in the middle of the day. Notice how the shade from the tree in the foreground adds contrast to the image, diffuses the light hitting the sheep's wool, and prevents it from getting overexposed.

INSTRUCTIONS

1. Explore the countryside, drawing inspiration from fields, wildflowers, animals, farmers, etc.

2. If you have travelled from the city, take some time to observe and tune into life in the country before you start shooting.

3. Capture subjects that are only present in the countryside, such as certain birds, insects, or plants.

4 Experiment with different perspectives, at ground level or from the crest of a hill.

TECHNIQUES

- Try making black-and-white images (film or digital) which can add drama and timeless quality to your photographs.

Depending on your camera:

- Shoot with a **macro lens** or **macro lens** setting to capture close-up details of flowers, animals, and insects.

- Use a **wide lens** to capture the expansiveness of the landscape.

- Play with a **fish-eye lens** for interesting **lens distortion effects** when shooting animals and the landscape.

- Consider a **zoom lens** which will give you more flexibility and create a comfortable distance from your subjects.

SHOT IDEAS

- Turn your lens to the rolling hills and vibrant meadows. Capture the vastness of the land.

- Chase chickens and piglets with your camera.

- Take portraits of farmers and workers.

Exercise 34: Open road

Who needs a destination? The wide-open road offers many attractions that can keep photographers well entertained on their journeys. Beyond the scenery, there are roadside diners, motels, lookouts, landmarks, characters, and other surprises.

My parents love road trips, and when I was little, they would tell me and my sister that we were going on a trip *sem destino* or without destination. This meant that they had a general idea of where we were going, but that we would let things unfold spontaneously along the way. Since then, I have taken many of my own trips around the world with that same adventurous spirit. I always make time for pictures and leave room for serendipity.

For this exercise, I invite you to hit the open road with your camera. The road is your destination.

This is a typical road shot that uses converging lines to lead the eye through the frame. It shows the expanse of the land and gives the viewer a sense of what it would be like to be on that road trip.

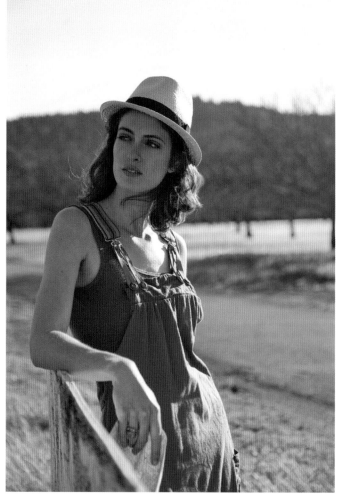

Including people in your shots is a great way to create context and help the viewer relate to the experience. Notice how the slight angle of her shoulders directs the eye to the background. Her position also allows for more illumination since the sun is coming from that side.

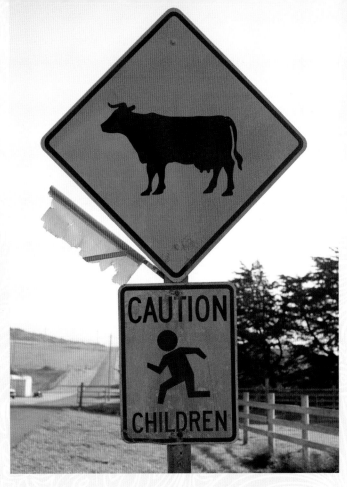

When photographing road signs, use a shallow depth of field to make it stand out from the background.

The black cow works as a graphic element because it really stands out from the background. The same shot taken with a white or brown cow may not have been as successful and impactful.

"Afoot and light-hearted I take to the open road, healthy, free, the world before me."

—Walt Whitman

INSTRUCTIONS

1. Experiment with different perspectives. Shoot the road from a perspective other than eye level or car level. For instance, you can shoot from a higher viewpoint or at ground level, close to the asphalt.
2. Capture interesting signs and roadside attractions.

TECHNIQUES

- Create a sense of depth by using **converging** and **leading lines** to draw the viewer's eye into your **composition**, by including a foreground element to your scene, and by **layering** elements.

Depending on your camera:

- Shoot with a **wide lens** to exaggerate the scenery.
- Consider a **zoom lens** to capture roadside subjects from a distance.

SHOT IDEAS

- Photograph animals crossing the road, such as sheep, cows, kangaroos, etc.
- Shoot from the backseat, to include the driver and the road ahead or shoot through the back window to record where you've been.

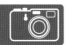

Exercise 35: Afar

While this book is mainly focused on capturing the beauty that is nearby and in our everyday lives, there are times when we will take our cameras further out into the world. Photography can help us connect with other cultures, embrace diversity, and find a deeper sense of meaning and belonging.

When I travel, I try to allocate ample time for taking photo walks on my own. As I mention throughout this book, we can only see something unexpected and interesting when we give ourselves the chance to really slow down and wander.

For this exercise, I encourage you to immerse yourself in your travels by cultivating the spirit of a curious explorer. Instead of being a tourist with an agenda, just wander!

NEAR RIGHT: This wide shot was taken from a train ride through the White Pass in Skagway, Alaska. Notice the interesting symmetry in how the mountains crisscross the frame and how the lighting, shapes, and textures create a layering effect that adds depth to the image.

OPPOSITE, TOP RIGHT: When photographing a scene that has been shot by many other photographers, veer off the path to capture your unique perspective.

OPPOSITE, BOTTOM RIGHT: Photograph local crafts or elements of historical significance. This image shows an Alaskan totem pole. Notice how it is more interesting and dynamic because both the writing on the wall and the window were kept in the frame.

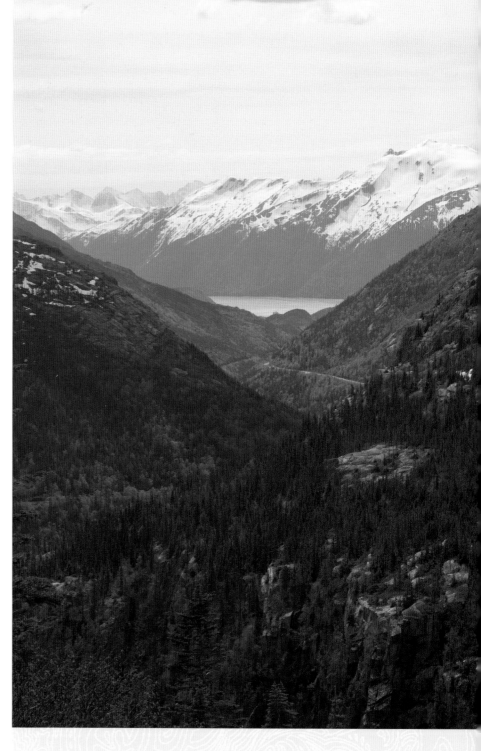

"I am not the same having seen the moon shine on the other side of the world." —Mary Anne Radmacher

INSTRUCTIONS

1. Before leaving home, research the local culture and points of interest at your destination.

2. Connect with locals to get the inside scoop on sights and events.

3. Try the local food. Food offers abundant photo opportunities.

4. Wait for the right moment. When visiting a location, do not rush. Linger until the lighting is right and all the elements come together. If needed, come back the next day.

5. At the same time, do not postpone your shots because things always change. This is true for any shooting situation, but it is especially relevant when travelling. The scene is never going to be exactly the same again. So if it looks amazing, shoot it then!

6. Veer off the beaten track and explore nontourist areas to capture real-life moments.

TECHNIQUES

- Every camera type adds lots of personality to travel shots. Consider packing more than one camera for a variety of looks. (See Chapter 1: Choosing Your Camera for ideas.)

- Use a special film for interesting effects. For instance, I once photographed a little town in Mexico with expired Time Zero Polaroid film. This film produced images with a greenish tone and the results were wonderfully nostalgic!

Depending on your camera:

- You may not want to bring a variety of lenses on a trip, so packing a **zoom lens** is a good idea because it gives you some flexibility. I always carry a standard **zoom lens** that ranges from a relatively **wide-angle** to a portrait-length **telephoto** (EF24-105mm f/4L) and a fast **standard prime lens** (EF50mm f/1.4 or f/1.2L) to use in low-light situations or when a **bokeh** is desired.

- If you have the room and motivation, pack a **tripod** for shooting in low light and to provide added stability in certain situations.

SHOT IDEAS

- Photograph a local activity or custom.

- Take pictures of the main square or town center.

- Capture everyday life as it unfolds in the middle of town or in the outskirts.

Chapter **5**

Senses and Feelings: Experiencing Life to the Fullest

Exercise 36:
Fresh flowers

Photographs of fresh flowers convey a blissful, almost scent-filled visual experience, and they express soothing and joyful feelings such as gratitude, reverence, and peace.

My favorite flowers to photograph are ranunculus, peonies, and magnolias, all of which bloom in the spring. I look forward to that time of the year when their scent and beauty infuse my house with a spirit of new beginnings.

For this exercise, I invite you to bring fresh flowers into your home for a photo shoot and for an affordable, uplifting experience. Visit a flower farm, pick wildflowers in a nearby field, stop by the farmer's market, or buy a small bouquet at your nearest flower shop. Arrange your flowers in vases, bottles, or mason jars. Distribute them around the house, perhaps placing one by the window, one on your dresser, and another on your office desk. Notice the floral scents, the burst of colors, and the cheerful atmosphere created by your freshly picked blossoms. Then, with input from all of your senses, take photos that infuse your images with your thoughts and feelings. Repeat as needed throughout the year!

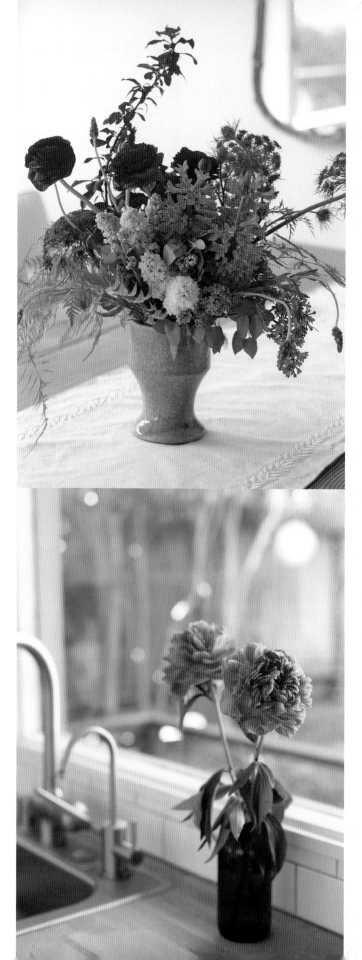

LEFT: Don't be afraid to crop the edges of your flower arrangement. Sometimes there are random branches sticking out that will hurt your composition. By all means crop in more closely if it works best for your shot.

OPPOSITE, RIGHT: For a fun variation, slide a gray card behind your flower arrangement. Notice how a dark background adds contrast and makes all the colors pop.

LEFT: Flower petals are easily overexposed. When shooting close to a window, choose a time when the sun is very soft or when the area is shaded but well illuminated.

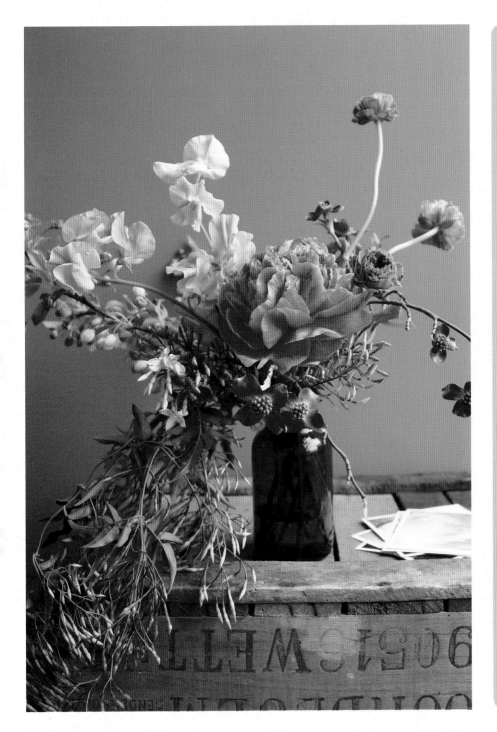

INSTRUCTIONS

1. Remember that flowers stand out best on their own or when juxtaposed against neutral and uncluttered backgrounds.

2. Look for natural light, which works best when shooting flowers.

3. Experiment with shooting a single blossom as well as more elaborate arrangements.

TECHNIQUES

- If desired, use a **reflector** to **bounce light** onto the shadow side of your flower arrangement to reduce contrast and to produce a softer, brighter, more luminous image. Alternatively, you can use a **black card** to create an even more prominent shadow side.

- Place flowers on a mirror or glass tabletop as a fun way to experiment with their reflections.

Depending on your camera:

- Capture close-up details with a **macro lens** or **macro lens setting**.

SHOT IDEAS

- Photograph a single blossom on your desk or light table.

- Capture a small arrangement on your dining table.

- Take a picture of a vase filled with freshly picked flowers near a window.

"I must have flowers, always, and always." —Claude Monet

Exercise 37: Soft to the touch

For many of us, our mother's soft and warm skin is the first thing we feel when we come out of the womb. Then for the first few months of our lives, we are wrapped in cozy blankets that help us feel safe in the world. Later, when we discover our own soft skin, we cuddle with our plush toys, carry our blankets, and perhaps play with a puppy or kitten. From the start, we naturally gravitate to what is gentle to the touch and what feels good on our skin.

As we continue to express sensations through imagery, I want you to call on the innate knowledge that you have of all that is soft. What does your body remember? Here are some of the things that come up for me: a baby's skin, my mother's hands, a kiss, a loving touch, snow, a summer breeze, grass, my pillow, sand, sheep's wool, cashmere, and velvet.

For this exercise, photograph what softness feels like to you. Focus on shooting something that gives you and the viewer a visual as well as a "tactile" experience.

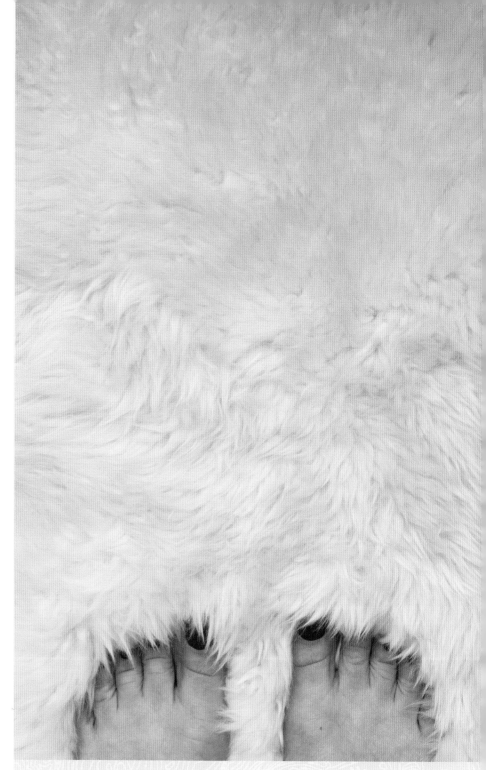

ABOVE: The way the feet are buried in the rug allows for a visual experience of softness. Reflect on the specific texture you are trying to capture and give it context so the viewer understands your intent.

RIGHT: Experiment with how light can bring out the nuances of a soft fabric and texture. Here the diffused light from the window wraps around all the textures like a soft embrace. The slouchy presentation of the sheep also helps communicate a floppy, soft state.

INSTRUCTIONS

1. Experiment shooting various textures: cotton, linen, wool, flannel, sheepskin, etc.

2. Notice how the lighting changes and highlights each texture.

3. Study how different textures can play off each other by combining them in your shot—for instance, fur on skin, sheepskin next to suede, etc.

TECHNIQUES

• Soft, diffused lighting is a must for capturing texture and especially for conveying softness. Observe the intensity and angle of the light that is illuminating your subject. The angle and intensity should create shadows that are noticeable and yet soft. Early-morning and late-afternoon sunlight provide the best lighting conditions for capturing softness. The harsh midday light will create strong shadows and obscure textural detail in the bright areas.

SHOT IDEAS

• Photograph a person wearing silk or cashmere—or silk *and* cashmere!

• Take a picture of a newborn, highlighting his or her soft, supple skin.

• Capture the tenderness of someone's touch or kiss.

"When the smooth softness of youth is replaced by the delicate softness of age, I will still want to touch your skin." — Laurell K. Hamilton, A Lick of Frost

Exercise 38: Taste

Food is an irresistible subject matter for photographers because it offers a chance to explore many aspects of our craft, such as lighting, color, texture, and **composition**. Food also connects us to different cultures and lifestyles and inspires travel and community.

I am most fond of food shots that go beyond a pretty plate. For me, the most successful food shots are those that I can almost smell, taste, and touch and that bring me a sense of comfort and familiarity. Experienced food photographers achieve this by focusing on styling and on visual appeal. They are impeccable about plating their dishes, they use natural light to highlight textures and sauces, they capture moisture and heat, and they style their shots with an emphasis on the experience of the meal.

For this exercise, I invite you to focus on your sensorial impressions of food. The next time you cook a special meal or dine at a favorite restaurant, notice what awakens your senses. Try to translate your experience and your feelings into your photographs.

INSTRUCTIONS

1. Capture more than just the food. Sometimes the context, the people, and the environment in which a meal takes place are the gateways to our senses and our feelings.

2. Look for spontaneous moments when people are experiencing food. Kids in particular taste and enjoy certain foods with enormous enthusiasm and sensorial delight.

3. Create your own styled food spreads. Add props and ingredients to enhance your images, but make sure the additions are relevant to the main dish.

4. For best results, shoot by a window to take advantage of any available natural light.

SHOT IDEAS

- Photograph a favorite dessert.
- Document a memorable celebratory meal.
- Capture the scrumptious mess of a street food dish.

TECHNIQUES

- Be fast. When the food begins to cool down or wilt, it is not as appealing.
- A soft sidelight or backlight works best for food shots.
- Enlist someone to serve the food to make the shot more interesting and dynamic.
- Use color and texture to heighten the sensory delight.
- Add realism to your shot by intentionally messing up what's on the plate as if someone were eating the food.
- Choose a background that complements the type of cuisine that's featured and to add contrast to the dish.
- Use a **tripod** for stability.

Depending on your camera:

- Use a large aperture setting to throw the background out of focus.
- Use a slow shutter speed to show movement when serving, mixing ingredients, etc.
- Use a **macro lens** or **macro lens** setting for getting extra close to capture details.

"It's so beautifully arranged on the plate—you know someone's fingers have been all over it." —Julia Child

While close-up food shots can show details of juicy, crispy, and saucy foods, wide-lifestyle shots can convey taste by featuring the surroundings and atmosphere in which the food was experienced.

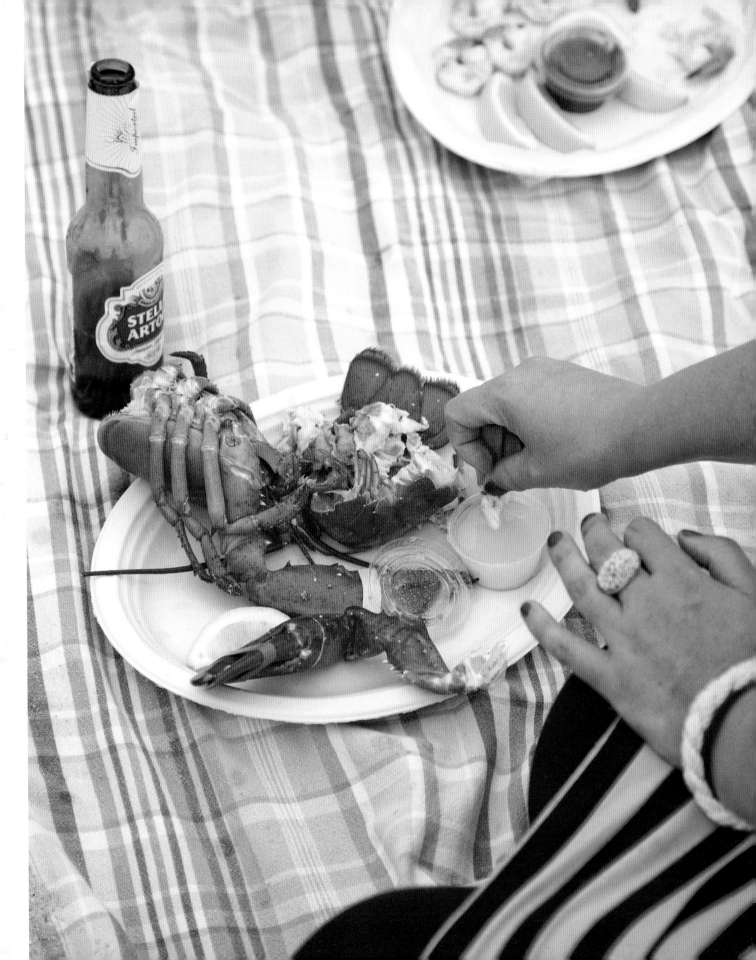

Exercise 39: A sound you love

Finding sounds that we love in our noisy modern world can be a challenge. But if we tune into sounds that are beyond alarm clocks, cell phones, and traffic, we may just find our bliss.

Let's use photography to investigate which sounds we want to hear more of in our lives. My favorite sounds are my daughter's voice and laughter, gentle waves, Ojai breathing, devotional chanting, Eddie Vedder's voice, Bossa Nova songs, and the incremental buzz of nature coming alive at sunrise in a tropical forest.

Sounds can also create a strong impression that takes us back to a particular moment or time in our lives. For instance, years ago I participated in a yoga retreat in India that was located right next to a lion sanctuary. Every morning when we gathered to meditate at sunrise, we were entranced by the sound of lions roaring! Ever since then, whenever I see an image of sunrise, I am taken back to that unforgettable place and experience, and I still hear the lions roaring.

What are some of the sounds that take you down memory lane, that touch your heart and awaken your soul?

ABOVE: After taking several shots with the guitar lying on a surface, I decided that it looked a lot more inviting when leaning against a wall. Aim to give your viewers the gift of an audiovisual experience. Remind them of a musical moment they've enjoyed or inspire them to pick up an instrument and play.

RIGHT: I used backlighting in this shot to avoid reflections on the screen. The headphones play an important role in adding to the visual experience of sound. Consider what props may support your ideas.

> "Sound has a profound effect on the senses. It can be both heard and felt. It can even be seen with the mind's eye. It can almost be tasted and smelled. Sound can evoke responses of the five senses. Sound can paint a picture, produce a mood, trigger the senses to remember another time and place."
>
> —Louis Colaianni, *The Joy of Phonetics and Accents*

INSTRUCTIONS

1. Make a list of some of your favorite sounds.
2. Gather the props and subjects you need to capture and express these sounds.
3. Head to a location where your favorite sounds can be heard and/or photograph your favorite sounds.

TECHNIQUES

Depending on your camera:

- Play with a slow shutter speed and a **panning** motion to convey the idea of sound waves or surrounding sound.

- Use a fast shutter speed if you want to freeze action (for instance, when shooting a performance).

- When taking photographs at a concert or a musical event in low light without a **tripod**, you will need to use fast film or bump your ISO to a higher number (800 or higher), and you will have to focus manually or use **AF-assist** (focus is challenging at low light). Shooting in manual will give you some flexibility when dialing the aperture and shutter speed, so you can achieve the best exposure while still avoiding a blurred image. The slower the shutter speed, the higher the chance for a blurred image without a **tripod**. Try to keep your shutter speed to a setting that is equal to or greater than the **focal length** of your lens (for a 50mm lens, use a shutter speed of 1/50th, 1/60th, 1/100th, etc). Alternatively, bring a **tripod** or place the camera on a stable surface.

SHOT IDEAS

- Photograph your favorite records.
- Capture birds singing.
- Take a picture of children laughing.

Exercise 40: Solitude

It is only in solitude that we can reflect on our lives and respond to the world around us without distraction from others.

As an artist and a mother, I am constantly craving alone time to create without noise, influence, and interruption. I have found that even in chaotic moments or when I am out with family and friends, I can find momentary relief when I spot a scene that evokes a feeling of oneness and stillness. It could be a glimpse of someone enjoying a contemplative moment, or it could be an object illuminated in a beautiful way that communicates a poetic state of singularity.

Find your own gateway to solitude by photographing someone or something that reflects your own feelings and your views of remoteness and seclusion.

RIGHT: The tracks on the sand and the bike lying on the ground add context to the story behind this shot. The slightly lower horizon line gives room to the textured sky, and the dead center composition works well with the strong silhouette of the main subject.

FAR RIGHT: The shallow depth of field in this shot helps the subject pop in the foreground, and it also conveys a dreamy, contemplative atmosphere.

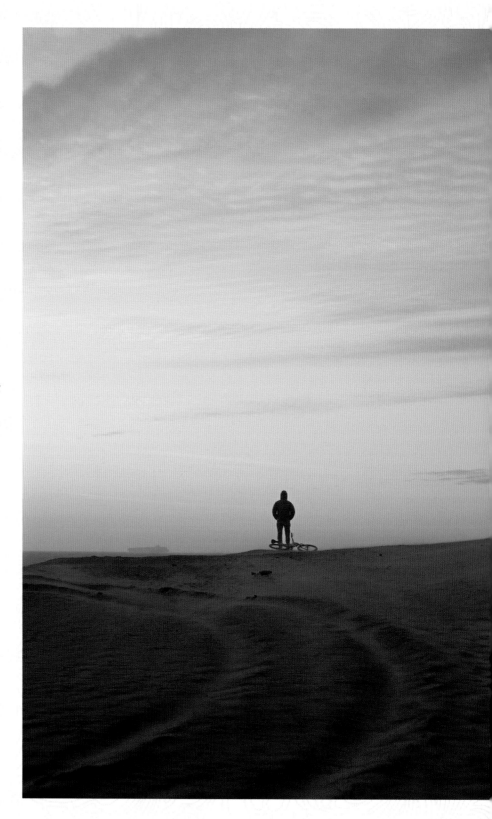

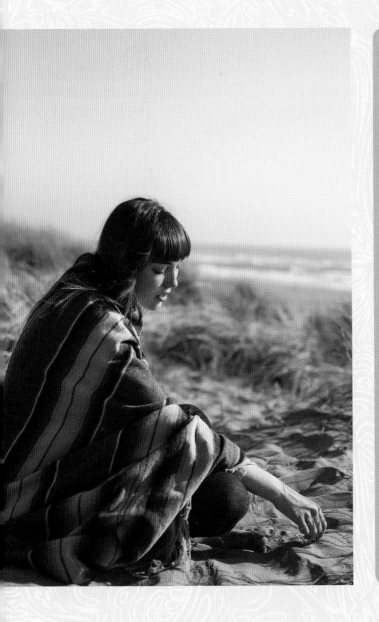

INSTRUCTIONS

1. Capture a moment of stillness, quietude, and reflection.
2. Photographing people from the back is an effective way to picture solitude and will prevent you from interrupting a spontaneous, quiet moment.

TECHNIQUES

Depending on your camera:

• A **zoom lens** will allow you to maintain a healthy distance from your subjects.

• **Silhouettes** or **partial silhouettes** portray solitude while simultaneously obscuring your subject's identity. **Metering** for the bright sky in the background will naturally make the foreground subject very dark. You can choose to dial your exposure to leave some detail in your subject (for a **partial silhouette**) or to make it completely black (for a **full silhouette**). Since you are obscuring details, it is important to arrange your subject in an interesting pose.

SHOT IDEAS

• Photograph a person reading on the beach.

• Capture someone gazing at the ocean, at the mountains, or at passersby.

• Take a picture of someone basking in the sunshine on a park bench.

"How much better is silence; the coffee cup, the table? How much better to sit by myself like a solitary sea-bird that opens its wings on the stake. Let me sit here forever with bare things, this coffee cup, this knife, this fork, things in themselves, myself being myself." —Virginia Woolf

Exercise 41: Comfort

Comfort comes in many forms. It may be soothing words, stories, and heartfelt conversations. It is in our lover's arms, our friend's smile, and our mother's embrace. It comes through listening for what we need and taking care of ourselves. (see Exercise 11: Self-care and pampering). It comes when we slip on a comfy sweater and well-worn boots. And it comes as a soft pillow for us to lay our heads on at the end of a long day.

In the self-care and pampering exercise, you photographed how you take care of yourself to stay healthy and energized. For this exercise, I want you go deeper into your senses and feelings.

Where do you find comfort and how does it feel? Does it make you feel held, warmed, loved, and protected? Photograph what brings you comfort. Infuse the image with your knowledge of how it makes you feel.

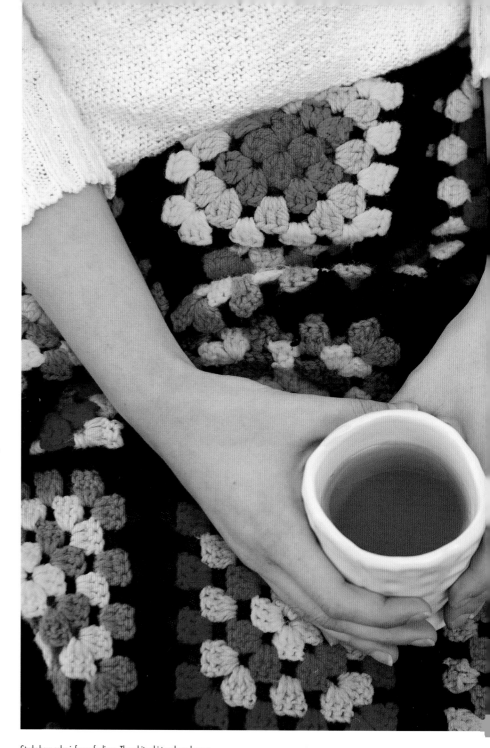

Study how color informs feelings. The white shirt and cup have a Zenlike quality and evoke peace, while the colorful wool blanket evokes warmth. Taken all together, these elements convey a sense of comfort.

INSTRUCTIONS

1. Experiment with colors and textures: Which colors are soothing and which are not? Are there fabrics or textures that make you feel comforted?

2. Notice how the lighting influences how you feel and how you perceive things. Warm, soft light tends to evoke a sense of comfort.

3. Use props to add mood to your images.

TECHNIQUES

- Use soft, diffused lighting to capture a warm, inviting feeling.

- Shoot during the magic hour (the last hour before the sun sets). Notice how the golden light wraps around everything, suggesting the feeling of a warm embrace.

SHOT IDEAS

- Photograph a quiet moment with a sleeping pet, a book, or a cup of tea.

- Take a self portrait of you wearing your favorite faded jeans and hand-knit sweater.

- Capture a moment of serenity and rest.

"Sometimes it was only a caress or a whisper of encouragement that reassured her childish heart, and sent her to sleep with a comfortable sense of love and protection, like a sheltering wing over a motherless bird." —Louisa May Alcott

Exercise 42: Simplicity

INSTRUCTIONS

1. Eliminate clutter from the background. Simplicity is best achieved with a clean background.

2. Balance can be challenging when shooting a single or a few subjects. Experiment with different angles and **compositions** to find the best balance for your shot.

3. Make sure to focus on your main interest.

TECHNIQUES

- Play off clever **framing**, strong lines, colors, and textures to strengthen your **composition**.

- Consider the **rule of thirds**.

- Try **juxtaposing** two strong elements.

- Place your emphasis on the **negative space** by making your subject very small within frame. This technique will evoke a dreamy, faraway feel.

Depending on your camera:

- Use a **macro lens** or **macro lens setting** and a shallower **depth of field** to separate your subject from the background and to highlight its features.

SHOT IDEAS

- Photograph a piece of fruit on the kitchen counter.

- Take a picture of a fallen leaf.

- Capture the **silhouette** of a bird on a telephone wire.

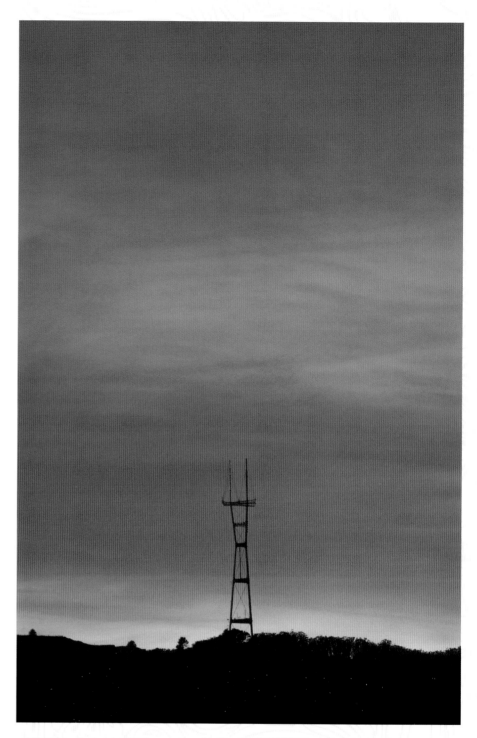

ABOVE: When working to capture simplicity, approach your shots like a designer and arrange a select few elements in a clever way.

RIGHT: Think like a minimalist. The silhouette of the tops of the trees is enough to pass on the idea of a forest, nature, woods, etc. The three horizontal lines of birds on a wire add an element of surprise to the shot and balance the composition.

Contrary to our natural inclination to fit as many elements as possible into the frame, keeping things simple can result in images that are strong, purposeful, and soulful.

Simple doesn't have to be boring. A single subject against a clean background can be utterly captivating. We can achieve simple and strong images by choosing interesting subjects and by making sure they stand out from the background.

When I want to create images that evoke simple beauty, I draw inspiration from Zen philosophy and the principles of *Wabi-sabi*, a Japanese aesthetic that promotes *fukinsei* (asymmetry), *kanso* (simplicity), *koko* (basic), *shizen* (natural), *yugen* (subtly profound grace), *datsuzoku* (unbounded by convention), and *seijaku* (tranquility).

I also feel moved by the Zen Buddhist concept of nothingness as explained by Leonard Koren in his book, *Wabi-Sabi: for Artists, Designers, Poets & Philosophers*: "All things are considered as either evolving from or dissolving into nothingness. This 'nothingness' is not empty space. It is rather a space of potentiality." When we capture simple, single, and small subjects, the empty space (background or **negative space**) plays a big role in the success of our photo. We can explore the potential of the background space by emphasizing its vastness.

For this exercise, I invite you to capture simplicity, a life lived simply, simple objects, and the concept that simple is beautiful.

"Simplicity is the ultimate sophistication." —*Leonardo da Vinci*

Exercise 43: Abundance

There are several ways that photography can bring abundance into our lives. The first and most obvious way is to use our camera to slow down, to notice, and to cherish every slice of beauty around us. Then, as we continue to shoot, we accumulate and gather more and more evidence that there is a limitless supply of inspiration and richness in the world. As we share our images, our work becomes a resource for others to nourish their own yearnings and to ease their fears of scarcity. Photography is also a great tool for visualization. By collecting images that represent the things that we need and desire, we clarify our desires and open ourselves to blessings and feelings of divine abundance.

What does abundance mean to you? Wealth, a full heart? What are the things that you crave more of in your life? Money, love, creativity? What do you feel enriched by? Good food, good friends, and good times?

Photograph life's unlimited graces, gifts, and opportunities for fulfillment.

ABOVE: Ponder how nuance can be useful to your shot. For instance, capturing the apples scattered across the ground as well as those filling the box communicates the idea that there is more than enough to go around.

RIGHT: Shooting a close-up is an effective way to express richness in color, scale, and quantity.

INSTRUCTIONS

1. Take a moment to jot down some words that you associate with abundance such as food, money, nature, etc.

2. Push yourself a bit further and tune into how abundance is manifested in your life: a plentiful fruit stand at the farmer's market (food), a new pair of expensive shoes (money), or a scenic view on a weekend hike (nature).

3. Work on a single image or a series of photographs over time. Picturing abundance is a way of cultivating gratitude in your life.

TECHNIQUES

- Take wide or panoramic shots to show how large the world is and all that it has to offer.

- Fill the frame with food and other elements in quantity.

- Shoot close-ups of your subjects to highlight their richness in color and texture.

SHOT IDEAS

- Photograph a room in which the light is abundant.

- Capture flowers blooming in the spring.

- Take a picture of a bakery counter or at a family feast.

"Abundance is not something you acquire. It is something we tune into." —*Wayne Dyer*

Exercise 44: Love

The placement of the couple at the center of the frame works well for this image given their pose and how they're gazing at each other. All the magic converges to center of their connection. Their expressions evoke joy, confidence, and love.

I saved love for last because while love is universal, it is also the most individual experience each and every one of us can have.

Poets, musicians, painters, photographers, and philosophers have explored the meaning of love through the centuries and will continue to do so forever more. The truth is that there are not enough words and images to exhaust the subject. We all feel and experience love differently, and we are capable of feeling many different kinds of love.

It just so happens that I typed this exercise on Valentine's Day, a time dedicated to celebrating love in the United States.

People buy chocolates, decorate cards, hold hands, kiss, and compose love notes. I spent part of the day at a café with my camera, pen, and paper, and I could not help feeling grateful for doing the kind of work I love best: writing, photographing, teaching, sharing, and inspiring.

As we conclude our 44 exercises exploring life, beauty, and self-expression, I invite you to document how love touches your soul, informs who you are, and how you interact with others and the world around you. Think about capturing a moment of self-love, romantic love, motherly love, or friendship love. Or perhaps you want to photograph something you love doing.

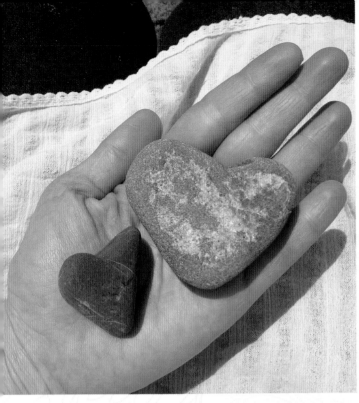

TOP: Heart rocks are a staple when it comes to photographing expressions of love in unexpected places. On your next adventure, keep a lookout for hearts. In the absence of an interesting backdrop, remember that your hands can also double as interesting and dependable backgrounds.

MIDDLE: This shot uses the heart bokeh technique. See the Technique sidebar in this exercise.

BOTTOM: When shooting couples in love, watch for body language. The way the bride and groom are touching heads in this shot expresses their connectedness. The groom's eyes are closed, allowing him to take in the experience, and her eyes are fixed on him. They are all smiles and their love is palpable.

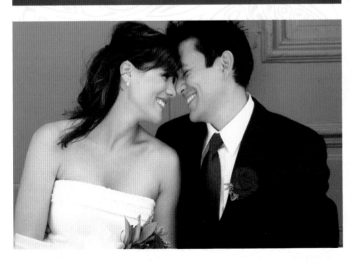

INSTRUCTIONS

1. Capture a connection, between parent and child, lovers and close friends.

2. Notice how love is being expressed. For instance, you can capture love in a hug, an expression, or a smile.

3. Photograph subjects you associate with love, such as hearts, words, certain lines of poetry, or newlyweds.

TECHNIQUES

• Review portrait techniques in Exercise 22: Traditions; Exercise 23: Play; and Exercise 24: Milestones and new beginnings.

Depending on your camera: Play with a heart-shaped **bokeh** effect.

• Use your filter to trace a circle on a black card. Cut the circle.

• Draw and cut a heart-shaped opening in the middle of the circle. The heart must be within the aperture of your lens. For a 50mm with a large aperture, experiment with a 25mm heart.

• Place the cut-out card against the filter on your lens.

• Set your camera to its largest aperture.

• Focus on a foreground element that has small lights in the background.

• Shoot to your heart's content!

SHOT IDEAS

• Photograph random hearts found unexpectedly, such as a heart-shaped rock, a leaf, a cloud, and so on.

• Photograph the word *love*.

• Take portraits of teenage couples, brides and grooms, and older people in love.

"We love the things we love for what they are."

—Robert Frost

Resources and Ideas

Here are some ideas for how to share your 44 weeks of photographs with others.

Printing

The traditional way of sharing photographs is to print and display them in albums (like our parents used to do!). But these days, there are many exciting alternatives. Here are some of my favorite printing projects.

Wall of Images: After completing all 44 exercises, look through your photos and select the 40 best images. Create a photomontage by displaying your images in five rows (or columns) of eight images each. You can display them on the wall above your bed, next to your desk, or along the hallway. Use one giant frame or post them on the wall unframed. Get creative! Use Fotoclips, photo decals, magnetic rope, and other gadgets to post your images onto the wall. Photojojo (www.photojojo.com) is a great resource for clever display ideas, gadgets, and accessories.

Photo Boxes: You can use a vintage box or an index card box to store your entire year in photos. Just think of the possibilities! You can have one box for each year or one box for each month.

Calendars, Datebooks, and Journals: Personalize your stationary using online printing sites. Paper Coterie (www.papercoterie.com) does high-quality, beautiful work.

Photo Transfers: Create photo transfers onto pillowcases, coasters, furniture, canvases, etc. There are many excellent tutorials online. I have compiled many of these DIY tutorials in my Pinterest account at www.pinterest.com/alessandracave/photo-printing-projects/.

Books: Create your own book inspired by *Shooting with Soul* using any of the online book-printing sites. My current favorites are Blurb (www.blurb.com) and Artifact Uprising (www.artifactuprising.com).

Mini-Cards, Stickers, and Magnets: Share your magic with the world by printing mini-cards, stickers, and magnets with the help of various websites. Some of my favorites are Moo (www.moo.com) and Stickygram (www.stickygram.com), which allows you to print photos from your Instagram feed.

Sharing Online

Although nothing can compare to the pleasure of holding tangible prints in your hands, in this digital era, there are many options for sharing your work online.

Galleries and Slideshows:

Consider Photoshop, Lightroom, and LightroomPro (my favorite application because you can add music to a gallery), and online at Picasa (picasa.google.com).

Blogs: Writing a blog is a great way to stay accountable and to get support and encouragement from a community. My favorite blog-hosting platforms for sharing photography are WordPress (www.wordpress.com), Square Space (www.squarespace.com), and Tumblr (www.tumblr.com).

Flickr: Flickr (www.flickr.com) is the premier website when it comes to online photo-sharing communities.

Instagram: Instagram (www.instagram.com) is the latest and greatest way to share images among smartphone users.

Impossible Project: At the Impossible Project (www.the-impossible-project.com), you can join a large, international community of instant photographers and participate in a pioneering mission to revive and preserve the art of instant photography.

Lomography: Lomography (www.lomography.com) is the place to learn about toy cameras and to participate in an international community of analog photography enthusiasts.

Soulful Communities

3191 Miles Apart
www.3191milesapart.com

Mortal Muses
www.mortalmuses.com

Project Life 365
www.projectlife365.com

Shutter Sisters
www.shuttersisters.com

Words to Shoot By
www.wordstoshootby.blogspot.com

Digital Cameras

Adorama
www.adorama.com

B&H Photo
www.bhphotovideo.com

Calumet
www.calumetphoto.com

Instant Cameras

Fuji
www.fuji.com

Land Cameras
www.landcameras.com

The Impossible Project
www.the-impossible-project.com

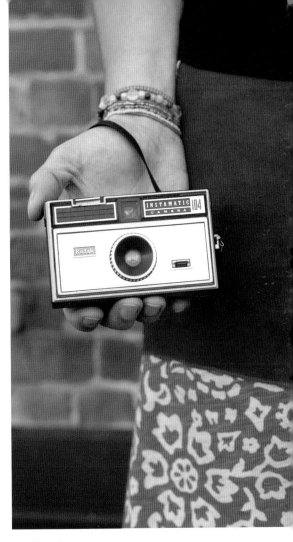

Toy Cameras

Lomography
www.shop.lomography.com

Camera Bags and Accessories

Epiphanie Bags
www.epiphaniebags.com

Ona Bags
www.onabags.com

Tenba
www.tenba.com

Glossary

AE lock: The auto exposure lock is a function present in some cameras that allows you to lock the exposure settings (and focus). This function is helpful when you want exposure continuity in panoramas or you want to expose the shot based on a particular meter reading.

AF assist: A function in many cameras that uses a beam of visible or infrared light to assist autofocus in detecting your subject at extreme low-light situations.

Angle of view: The angle of view is measured in degrees, and it determines how wide the lens can see. See *field of view* and *focal length*.

Auto focus: A feature in most digital cameras that automatically adjusts the lens to achieve focus (sharpness) on the main subject or focal point.

Black card or white card: Black or white cards can be made out of mat board or fabric. They are usually placed on the shadow side of the subject to either increase (black card) or decrease (white card) its contrast.

Bokeh: The blurred quality in a background that is out of focus. You will need to use a fast prime lens at a large aperture setting (f/1.8 or larger) to achieve a nice looking bokeh. Good bokeh makes the subject pop in the foreground while bad bokeh can be distracting.

Bounce: The light that is reflected onto a subject by a wall, reflector, card, fabric, etc.

Camera shutter/shutter: The camera shutter works like a window shutter, opening and closing to control the duration of each exposure.

Composition: The art of successfully arranging elements within the frame.

Depth of field (DOF): That which determines how much of the image will be perceived as being sharp, or how deep your focus is going to be. You will need a large depth of field to have your subject and background in focus, and a small or shallow depth of field to have a sharp subject in the foreground and an out-of-focus landscape in the background. There are several factors that determine the depth of field: aperture setting, type of lens, and distance between the subject and the camera.

Diffuser: When placed between the subject and the light source, a diffuser is a tool used to spread and soften the light, reducing its harshness. Clouds and trees are natural diffusers. Other types of diffusers include scrims, umbrellas, lightboxes, sheets of fabric, flash domes, grids, etc. See *scrim*.

Digital processing: Once digital images are downloaded onto a computer, they go through a digital processing phase. This step may include cropping, resizing, making look adjustments, retouching, changing file format, etc.

Exposure: The amount of light allowed into the sensor or film. Too much light causes the image to be overexposed, and insufficient light causes it to be dark. We balance exposure by adjusting aperture, shutter speed, and ISO.

Field of view (FOV): The field of view is based on the lens angle of view. It is what you can see in the frame when you look through the viewfinder at a particular camera position. See *angle of view* and *focal length*.

Fill light: A secondary light source, softer than the main light, which is used to fill in and brighten the shadow areas of an image. It can be a flash burst (fill flash) or a bounce. See *bounce* and *reflector*.

Film grain/noise: Film grain is the texture of processed film, and noise is the equivalent pixel effect in digital photography. A grainy or noisy image has a static look with larger and more evident grain or pixels.

F-number: The f-number indicates the size of the opening in the lens (aperture) and the lens speed. A small f-number (f/2.8 or smaller) stands for a large aperture, and a large f-number (f/8 or larger) stands for a small aperture. A lens with a maximum large aperture (small f-number) is considered a fast lens.

Focal length: A lens is basically defined by its focal length, which is measured in millimeters (18mm, 35mm, 50mm, 85mm, 200mm, etc.). The important thing to know about a lens focal length is that it informs how wide the lens can see and how large the subjects will be in the frame. In other words, it determines the lens angle of view.

Focal point: The main interest and subject of an image.

Framing: A composition technique that uses frames, such as windows, doorways, branches, tunnels, holes, etc., around the main subject to draw the viewer in, to create context and interest, and to add depth to the image. Framing is also used to describe how the shot will be composed in general.

Juxtaposition: A composition technique that uses contrasting elements side by side to add interest to an image, such as old against new, natural against man-made, young against old, etc.

Leading lines/converging lines: A technique used to create stronger compositions by using lines present in a scene to "lead" the viewer's eye through the picture. Converging lines come close together or to a point.

Lensbaby: A line of lenses designed for photographers interested in exploring selective focus (only a small area of the shot in focus) and creative optic effects.

Lens distortion: An effect commonly created by wide lenses and wide-range zoom lenses that bends straight lines inwards or outwards.

Lens flare: An effect created when shooting toward a bright light source, most commonly the sun. It manifests as colorful streaks, geometric shapes, and a haze. It can ruin the image or make it more artistic, depending on how it is used and how the image turns out.

Levels: Digital processing programs such as Photoshop have a levels adjustment tool that allows you to manipulate the intensity of shadows, midtones, and highlights of an image.

Light trails: Streaks of light captured when lit, moving subjects, or traveling lights are shot with long exposures.

Macro mode: An auto mode variation offered by some cameras. It is usually indicated by a flower icon, and it allows you to take close-up shots of your subjects.

Manual mode: A shooting mode in which the photographer has full control of all settings, including aperture, shutter speed, ISO, white balance, etc. Other shooting modes include auto (the camera controls all settings), Av mode (the photographer controls aperture while the camera controls the other settings to expose accordingly), Tv mode (the photographer controls shutter speed while the camera controls the other settings to expose accordingly), and P (the photographer controls some settings, such as ISO and white balance).

Metering: The system used to measure the available light in a scene and determine what settings should be used for optimal exposure.

Negative space: The empty area around the image's main subject.

On-camera flash/in-camera flash: An on-camera flash is a type of flash unit that can be mounted onto the camera's hot shoe, but that can also be used off camera. This type of flash offers the photographer more control and covers larger distances than the in-camera flash (the built-in flash common in most compact cameras).

Panning: A horizontal rotation of the camera as it follows a moving subject. It is used to convey movement, keeping the subject sharp over a motion-blurred background.

Pattern: A composition technique that uses the repetition of interesting subjects, shapes, colors, and lines to create visual rhythm and balance in an image. Breaking a pattern is also an effective way to add impact to a composition.

Polarizing filter: This nifty accessory can be attached over your lens to filter out reflected light. It reduces reflection and glare while increasing contrast and saturation.

Portrait mode: An auto mode variation offered by some cameras. It is usually indicated by a face icon, and it automatically uses a large aperture setting to create a shallow depth of field and emphasize the main subject.

Raw mode: As the name suggests, raw is a type of image file that is minimally processed by the camera. While most digital cameras take the original RAW images captured by the sensor and automatically process and convert those images into a file format that is ready for printing (JPEG or TIFF), some newer cameras offer the photographer the option to process the RAW files themselves. This option gives the photographer more control over his or her final images since the RAW image files contain a lot more color information as well as a higher dynamic range (light-to-dark ratio).

Reflector: A reflective surface such as a wall, white board, or sheet of fabric that is used to redirect light or bounce light onto a subject.

Rule of thirds: Imagine that your image is divided in thirds by two vertical lines and two horizontal lines. The rule of thirds is a principle based on the idea that images are more interesting when the main subject is placed near or where these imaginary lines intersect.

Scrim: A type of light diffuser that consists of a piece of scrim fabric stretched over a square or rectangular metal frame. Scrims are used to soften or change the qualities of the light.

Shapes: A composition technique that uses geometric shapes to add interest to an image.

Starburst effect: When you shoot toward a bright light source using a small aperture setting (such as f22), the light bends as it goes through the small opening of the lens and around the blades. This bending is called light diffraction and it results in exaggerated light rays, making the light source look like a star.

Silhouettes/partial silhouettes: A silhouette consists of a dark or black main subject against a very bright background. A partial silhouette shows some detail in the subject, while the full silhouette features a completely black shape in the foreground.

Studio strobes: Large flash units that are used in studio photography. Strobes work in sync with the camera via wire or remote, emitting short bursts of light when the camera shutter is released.

Symmetry: A composition technique that uses identical elements on either side of the main subject to create a balanced and harmonious image.

Tripod: A three-legged stand that supports the camera when stability is desired or required.

Tripod arm: A metal bar used to extend the camera over the set. It is used so that the tripod legs do not appear in the shot when shooting from overhead, and it is a helpful tool when there is a need for continuity in the framing and styling of overhead shots.

Viewfinder/LCD screen: In most cameras the viewfinder is the tiny square used by the photographer to look through, frame, and focus the shot. In addition, many digital compact cameras offer an LCD screen on the back that can also be used for framing and focusing.

Special thanks

123 Local
Ace Hotel Palms Springs
Alexis Hutt
Blackwell Files
Diana Fayt
Elizabeth Gunst
General Store
Gorgeous and Green
Helena Bianca
Makeshift Society
Micaela Hoo
Ona Bags
Outerlands
Studio Choo
Tanya Kandohla
The Cro Cafe
The Mill
Trouble Coffee
Yoga Tree, Hayes Valley
Windrush Farm

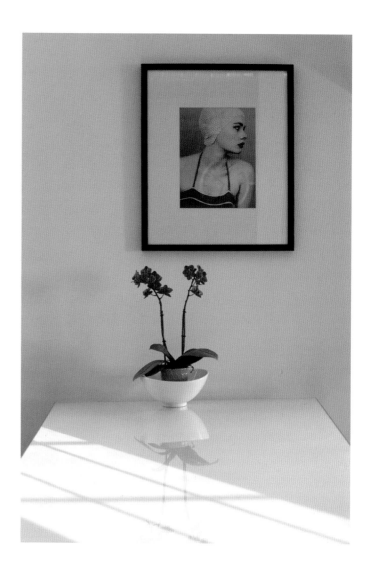

About the Author

Originally from Brazil, Alessandra Cave thought all she needed was a camera and a backpack until her round-the-world travels revealed a fierce love for texture, light, and design. After working for over 12 years as a producer in the film industry, Alessandra kissed her cubicle good-bye in 2009 to pursue her dream of working as a professional photographer. She currently lives in San Francisco and splits her time between working on photography assignments, teaching workshops at creative retreats, and raising her amazing daughter, who is her greatest creative achievement to date. Alessandra holds a Master of Arts degree from the Savannah College of Art and Design, but she considers herself completely self-taught when it comes to photography. A contributor to Shutter Sisters, the widely acclaimed photo blog celebrating women photographers, Alessandra is passionate about inspiring and empowering women to pick up a camera and follow their creative dreams. Her work has been featured extensively on the Internet as well as in national and international publications, including *The Beauty of Different*, *Nine to Five*, *Artful Blogging*, *Somerset Studio*, and *Mingle*. You can follow her work and journey at www.alessandracave.com.

Acknowledgments

I am grateful to everyone who has touched my life in a magical, nourishing, and inspiring way. Thank you, Mary Ann Hall, for believing in me and in my work, and for being a dream to work with. Thanks to the entire team at Quarry for taking on my ideas and turning them into reality. Thanks, Regina Grenier and team, for a gorgeous design, and Betsy Gammons for bringing it all together. Nancy King, for wordsmithery and a sense of humor. Thanks to Mary Aarons for being a fabulous student and for opening doors. Thanks to Ali de John for believing that I could teach, and for being such a great role model. Tracey Clark, for encouraging me to bring all of myself into everything I do. Myriam Joseph, for love and nourishing words. Jen Lemen, for helping me to see my higher self within. Brené Brown, for that handful of courage you gave me in Martha's Vineyard. Jen Gray, for loving and listening. Mati Rose, for introductions. Stephanie Watanabe and Jennifer Lee for holding the dream with me early-on. All the lovebombers, for bravely sharing your heart with the world and inspiring me to do the same. Stefanie Renee, for modeling and lending props. Lee Rase, for cheering me up along the way. Robbi and Jackie, for letting me shoot at your home. To Marianne Elliott, for sisterly love, support, and wisdom. Thanks to all my friends in the film industry. I feel so lucky to have had the chance to work with each one of you. You taught me so much about attention to detail, process, and image making. Thank you, Trinette, Chris, Erin, Jenny, Yumi, and Heather, for teaching me the professional ins and outs of photography. It has been an honor to learn from you. Thanks to all those who contributed their time, cameras, advice, spaces, and props. Shane and Jessica Tang, for letting me share your wedding day. To Carla, for being an amazing friend and for taking such good care of me and my little one. And last but not least, I want to thank my family: my mom, Lucia, my dad, Edison, and my sister, Andressa. Thank you for your unconditional love and for teaching me about hard work, faith, and perseverance. Thank you, Betsy and Ken, for your practical wisdom and encouragement. A special thanks to my husband, Richard Cave, for being my first reader, my soundboard, and my true love. Finally, thank you, Gabriella, my sweet daughter. Thank you for bringing light, hope, and joy into my life every single day. This book is for you. You are my biggest source of inspiration. I love you and I feel incredibly lucky to be your mom.